G.P. Mynott
Dunwoody Village CH-122
3500 West Chester Pike
Newtown Square, PA 19073

M. Schwartner

PAINTING
Glowing Colors
IN WATERCOLOR

Penny Soto

NORTH LIGHT BOOKS
CINCINNATI, OHIO
www.artistsnetwork.com

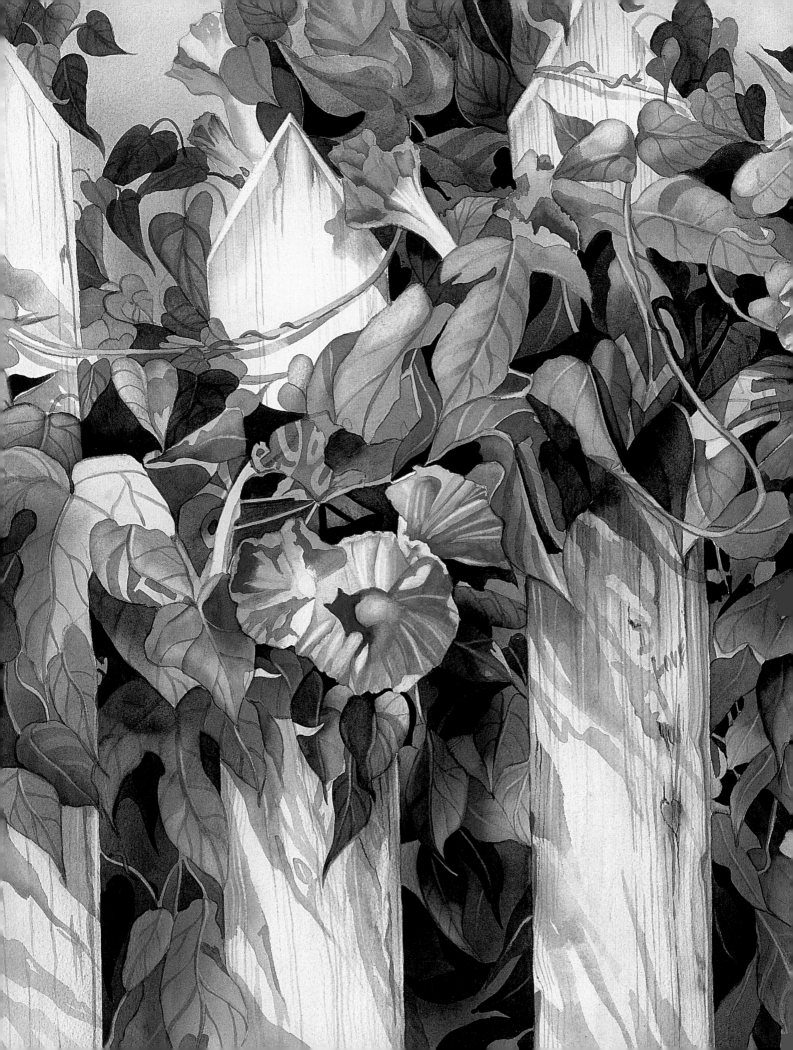

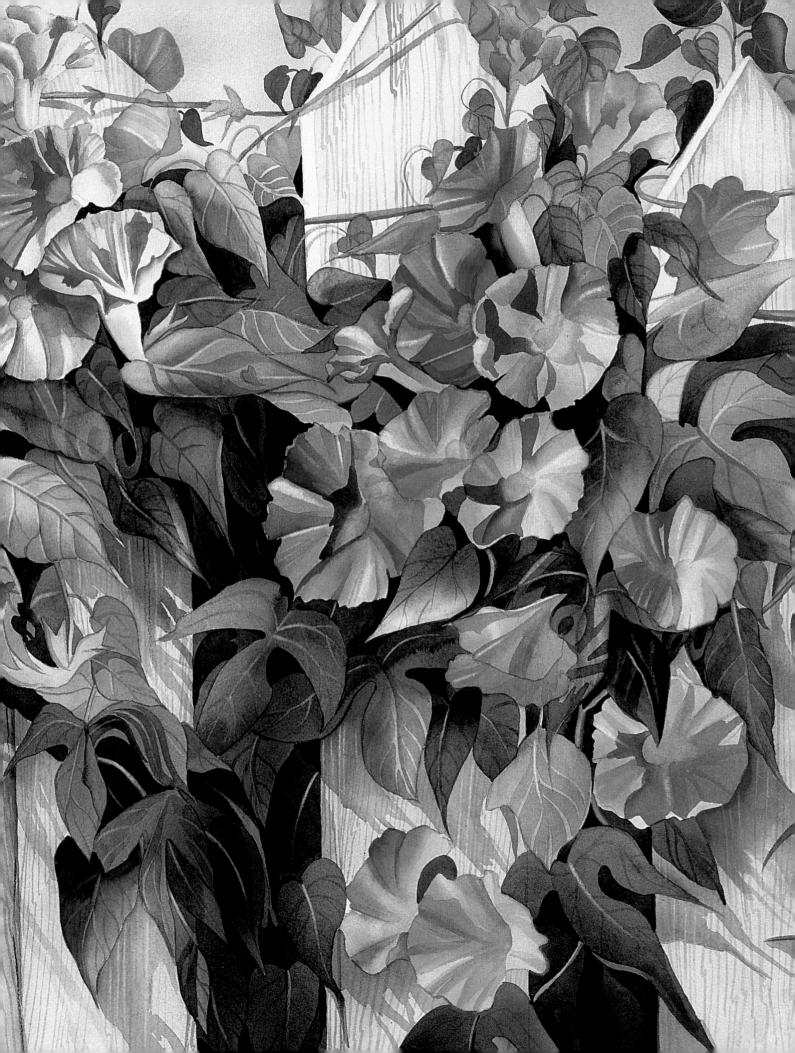

Penny Soto is a native of California who lives and works in beautiful Pollock Pines near Lake Tahoe with her husband, Paul. She pursued a career in fine art and illustration at the San Francisco Academy of Art and has been professionally painting, teaching and lecturing since 1980. Penny is one of the most recognized up-and-coming artists and has had many gallery and museum exhibits in her career. She has earned over 250 awards and honors, including the prestigious San Francisco Academy of Art Scholarship award.

Penny has painted for many private and corporate collectors across the country. Her work can be found in the collections of Nordstrom's, Pepsi-Cola, Pacific Bell, The Kaiser Foundation, Nestlé Purina PetCare Company and several others. She is a member of many associations, including, the San Francisco Society of Illustrators, the Los Angeles Society of Illustrators, and is a signature member of the California Watercolor Association.

Penny's work has been featured in *The Artist's Magazine, The Decorative Magazine* and *Air Brush Action.* She has also appeared in *The Best of Flower Painting 2* (North Light Books, 1999) and *Creative Computer for Artists* (2002). She writes a monthly step-by-step article for www.worldofwatercolor.com and www.artmagazine.co.uk. Her profound use and love of color prompted her to design, patent and produce a special watercolor palette that holds 84 colors and spins for easy access. Her palette and her artwork can be seen on her website, www.sotofineart.com.

Painting Glowing Colors in Watercolor. Copyright © 2003 by Penny Soto. Manufactured in Singapore. All rights reserved. No part of this book may be reproduced in any form or by any electronic or mechanical means including information storage and retrieval systems without permission in writing from the publisher, except by a reviewer who may quote brief passages in a review. Published by North Light Books, an imprint of F&W Publications, Inc., 4700 East Galbraith Road, Cincinnati, Ohio, 45236. (800) 289-0963. First Edition.

Other fine North Light Books are available from your local bookstore, art supply store or direct from the publisher.

07 06 05 04 5 4 3 2

Library of Congress Cataloging in Publication Data
Soto, Penny,
 Painting glowing colors in watercolor / Penny Soto.— 1st ed.
 p. cm
 Includes index.
 ISBN 1-58180-215-3 (hc. : alk. paper)
 1. Watercolor painting—Technique. 2. Color in art. I. Title.

ND2420 .S635 2003
751.42'2—dc21 2002027867

Edited by James A. Markle
Designed by Wendy Dunning
Production art by Karla Baker
Production coordinated by Mark Griffin

METRIC CONVERSION CHART

To convert	to	multiply by
Inches	Centimeters	2.54
Centimeters	Inches	0.4
Feet	Centimeters	30.5
Centimeters	Feet	0.03
Yards	Meters	0.9
Meters	Yards	1.1
Sq. Inches	Sq. Centimeters	6.45
Sq. Centimeters	Sq. Inches	0.16
Sq. Feet	Sq. Meters	0.09
Sq. Meters	Sq. Feet	10.8
Sq. Yards	Sq. Meters	0.8
Sq. Meters	Sq. Yards	1.2
Pounds	Kilograms	0.45
Kilograms	Pounds	2.2
Ounces	Grams	28.4
Grams	Ounces	0.04

Lost Loves · *30" x 40" (76cm x 102cm)* · *Collection of Renee Lynn Soto* · *Art from pages 2-3*

Dedication

This book is dedicated to my husband, Paul, whom I admire greatly and without whom I would be nothing. He encourages me, helps me and does everything he possibly can to make my life as an artist easier. I love him dearly for this. To my son, Paul Richard, who is very proud of me. To my son-in-law, Gabriel, who has a great eye and is not afraid to tell me what he thinks. To my new daughter-in-law, Kathy, who encourages me always. And last, to my daughter, Renee Lynn, who is my inspiration in life.

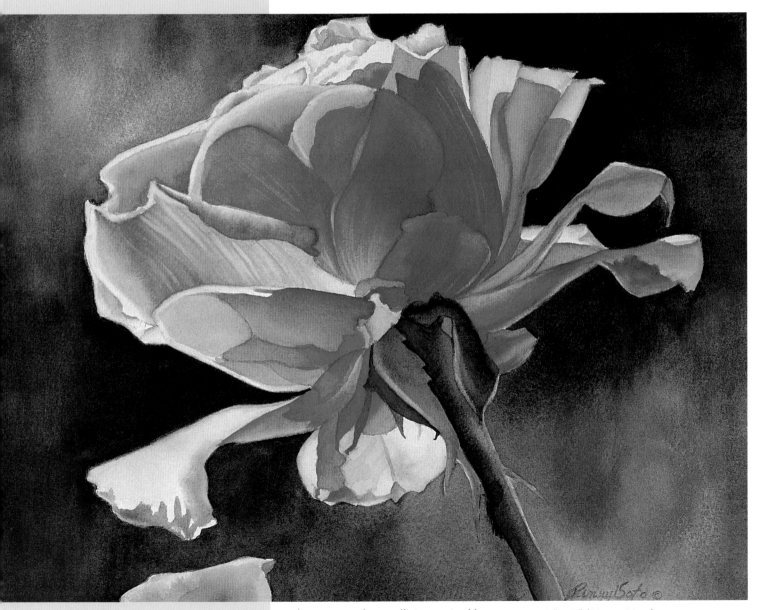

The Rose · Arches 300-lb. (640gsm) cold-press paper · 11" x 15" (28cm x 38cm)

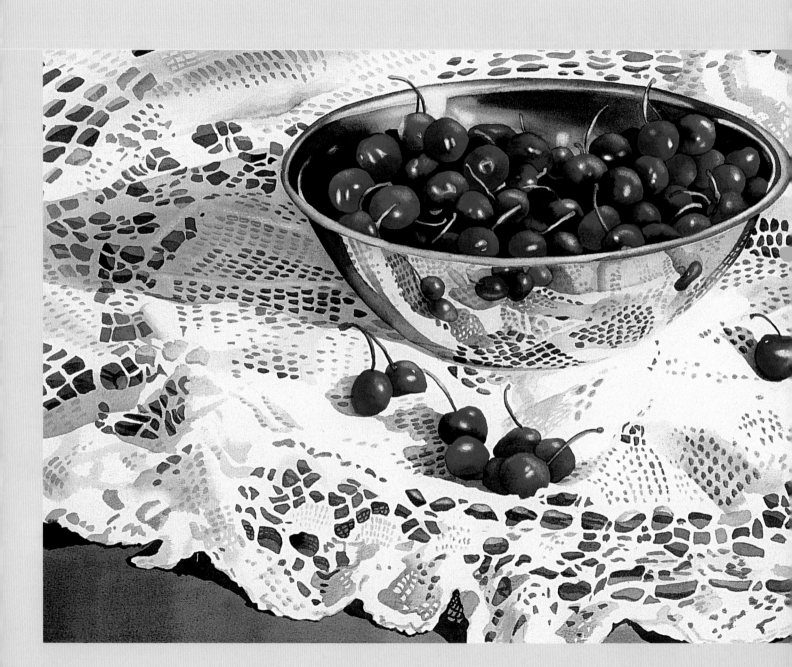

Acknowledgments

First and foremost, a special thanks to Rachel Wolf and Jamie Markle, the best editors in the world! They are the greatest. And a very special thanks to the staff at North Light, you did a remarkable job putting this book together and keeping me together.

This book took the better part of a year and a half to complete. I have to say, I loved every minute of it. I want to thank my family for their patience when I wasn't listening to them at all, but just thinking about the book. They are the best family a person could ever have and I am truly grateful for them. A big thank you to my special husband; without him there would be no book. For all the endless help of getting film, developing it and running back and forth, I owe part of this book to him. A simple thank you just doesn't seem to be enough. He made me question myself, think long and hard about things and helped me to write and paint from within my heart. He brought out all these things in me I didn't know I had and made me do them right. He is the best. Thank you, Paul, for believing in me.

And thank you so much to my students for putting up with me when my mind was long gone towards the end of the book! You are all inspirations to me. I love you all dearly and am so very proud of you—Joan, Beverly, Joyce, Heide, Linda, Shirley, Cookie, Kim and all the other students who keep me going and on my toes—you're the best!

Thank you to my teacher, Juan Pena. You taught me to do things right and opened my eyes to see color. Your words from twenty years ago still ring in my head. Thank you for being such a great artist and teacher. You are the best and always will be.

A special thanks to Jim Ferriera for the wonderful photography, you are an artist in your own right with loads of talent.

Thanks to all my dearest friends: Marti, my "bestest" friend; Tweetie, thanks for all your advice and help; Phyllis, my workshop sister; Nancy Thompson; Shirley and Jody Fleischman; Sal Sanchez, my greatest collector; Denise Sperry; Bobby, my agent; Denise Rinkle, you are the best; Bea and Joe O'Brien; Vicki Richardson; and Harlan Tillman, my best friend and great model who sat for hours on end for me and my classes.

To the editors of www.worldofwatercolor.com, Gloria and Paul Angelino, you are too wonderful. To my web designers, Sharon Hines and Brian Matney, and to Marc in the United Kingdom, a pond away—the editor of www.artmagazine.co.uk—for your friendly advice. You were all there for me and I appreciate it.

A very special thanks to a very special artist, Sabina Turner. She is an inspiration to me as a person and as an artist. She's the best of the best. Thank you, Sabina, for all your wonderful advice and critiques.

A big thank you to Theresa Connoley for teaching me photography in one easy lesson! You're a great photographer, a good artist and a wonderful person.

And last but not least, thank you with love to my children, Paul and Renee, Gabriel, Kathy and Devan. You all have loved and helped me so much. You have made my painting a joy. Thank you for believing in me. I love you very much!

Cherries Jubilee • *Watercolor on 300-lb. (640gsm) cold-press paper* • *22" x 30" (56cm x 76cm)*

Table of *Contents*

A Professional *Start*

Organizing your paints ❧ Brushes ❧ Paper Setup ❧ Additional Supplies

Understanding *Value*

Recording Your Image ❧ Photography
Crop Your Image ❧ Thumbnail Sketches
Create a Value Sketch ❧ Create a Ghost Image
Value Chart

The Personalities *of Color*

Intensity of Colors ❧ Transparent and Sedimentary Colors
Opaque vs. Transparent Colors ❧ Complementary Colors
Blacks and Neutral Colors ❧ Color Temperature
Distributing Color Temperature ❧ Color Chart

Controlling *Color*

The Wash ❧ DEMONSTRATION: Flat Field Wash
DEMONSTRATION: Flat Field Wash Within a Painting
DEMONSTRATION: Blending Colors on the Paper
Variations of the Flat Field Wash

Introduction

There are sparks of inspiration all around us—all we have to do is look. Each day brings something new, exciting and inspiring. As artists, we have to train our minds and feel in our hearts to see these things. Lighting, color, emotion, drama—all these things add to the excitement of being an artist. When you paint, it should come from your heart with happiness.

However, watercolor is a medium that is noted for its difficulty and frustration. And I'll be the first one to agree with that. It doesn't have to be that way if you learn the basic techniques and the properties of your materials. If you invest time and money in getting the best supplies and education, you will be off to a great start. In these pages I will teach you the basics of watercolor, how the materials are used and what they can produce. Hopefully, you will keep these lessons always in your heart.

I will show you how to paint with enthusiasm, happiness and creativity—not just how to copy from a photograph—but how to look into the color to put your heart and soul into your work. You can only achieve this once you pass the frustration mark and learn the basics and all that watercolor materials will do. Then you can express your creativity and imagination in your work.

White Hollyhock · *Watercolor on Arches 300-lb. (640gsm) cold-press paper* · *30" x 22" (76cm x 56cm)*

A Professional
Start

My materials list is rather simple. I use Arches 300-lb. (640gsm) cold-press bright white, Crescent cold-press 100 illustration board and Fabriano Uno 300-lb. (640gsm) cold-press paper. I like the tooth of the Arches paper, plus it is very durable and can be scrubbed. The softness of Fabriano Uno is wonderful and very compatible with some techniques, like airbrushing.

I use a variety of different paints based on years of experience and study of what they will do. Manufacturers are continuously coming out with new pigments. It's essential that you see what each color's personality is and what properties it has. You should know the properties of each of your colors. I will help you create a color topper—a must in learning your colors.

There are 1,001 brushes on the market. After trying several hundred, I believe you must be comfortable with the brushes you use. I like short-bristled, firm brushes. I also use an acrylic brush that is very compatible with my style of working and can be used for many different techniques. I don't use extremely small brushes; if you learn to control the tip of your brush you do not need to change to a smaller one. The paint also flows better with a larger brush, allowing you to be more creative. Larger brushes also discourage the tendency to noodle—the pitter-pattering of a brush or continuously overworking one spot that doesn't need attention.

Remember, painting and being an artist is a special gift. However, we have only a certain amount of talent; the rest, your education, is up to you. Exploring new subject matter and techniques as well as opening yourself up to new challenges keeps you growing as an artist. In this book I will try to convey to you some of my trials, errors, successes and fulfillment that being a watercolor artist has given me. So let's get started!

Evolution of An Artist · *Watercolor on Arches 300-lb. (640gsm) cold-press paper*
22" x 30" (56cm x 76cm)

Organizing *Your Paints*

COLOR IS KEY

There are so many new truly beautiful colors on the market today. I use a lot of different brands and colors in my work. I especially like the Quinacridones and some of the newer MaimeriBlu colors, they are so beautiful and have a lot of strength to them. Some of these colors cannot be recreated no matter how hard you try.

❧

Being organized is very important for an artist. I use so many colors that if I didn't have a good plan to keep them organized I could never keep track of them all.

Paints

The first thing on your priority list as an artist should be finding the right materials. There is a big difference between student-grade and professional-grade paints. Student-grade paint has more additives in it, which causes a weaker intensity of pigment and less light fastness. Professional-grade colors are brighter, truer and more vivid. I tell my students to compare them to workman's tools. You can use an inexpensive brand or you can use a top-of-the-line brand that lasts longer and does the job right. I recommend professional-grade paints for both the beginner and the advanced artist.

When I was learning the basics of painting, my teacher had me use only the primary colors—red, yellow and blue. I learned color mixing, which was essential, and eventually began to see color all around me. As I noticed more and more color, I began to relate what I saw to the pigments in my palette and purchased more colors that resembled what I saw. Through the years I have narrowed it down to the color families I like. Some artists prefer a very limited palette—that's OK for them. In my work, I find the more colors I use, the more exciting things become and the more I get to mix unusual colors. I want my paintings to be colorful and different.

Color Families
It took me a long time to acquire all these colors. They are each a little different from one another and mix wonderfully. I keep this color chart handy when I am painting. Notice how each color is painted using three values. This helps me know what each color will look like when dry. The lighter tints of the colors look very different than the darker tints.

Create a replica of your palette, including one box for each well of paint. Make this the same size as your palette. They should match up when you put the lid on the palette.

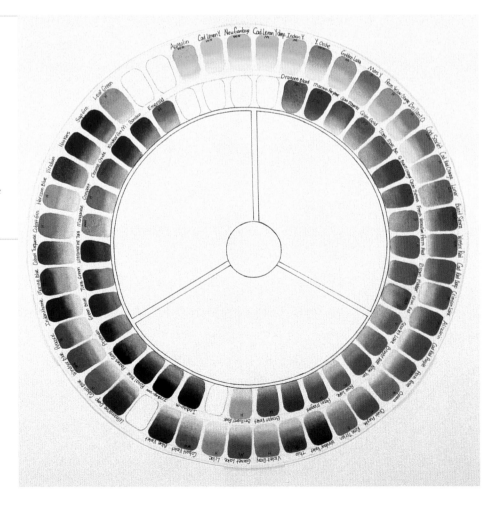

It's good to have a lot of color on your palette as long as you recognize the temperature, compatibility and personality of each color and what it can do. The more colors you have, the more beautiful mixtures you can make. The possibilities are endless!

It is impossible to purchase all of these colors at once—I didn't. Whenever I went to a workshop I was always on the lookout for new colors; I tried other students' colors and let them try mine. It's a great way to try colors without purchasing something you may not want or already have under a different name. You can begin by purchasing a warm and a cool of each of the primary colors—red, blue and yellow—and secondary colors—green, orange and purple—that is enough to get you started.

Palette

I have designed and patented a special palette that holds all my colors. This allows me to group my colors by color families or hues. With this palette I can be organized and spin to the color I need without wasting time. It is called Spin-A-Color™. There are 84 wells in my circular palette, which also has a brush holder and attaching water container with four separate divisions. No matter what palette you choose, make sure your paints are organized and accessible.

Color Topper

It's a must to make a color topper for your palette. Cut a piece of your favorite watercolor paper—the kind you use the most—the same size as your palette. Draw the

wells as they appear on your palette; they should match up when you put the lid on the palette.

Take each color and paint the area with three values of the pigment—light, medium and dark. Use a ten-point value scale (see page 29) to start your gradations. Ten is the darkest, most saturated color; one is the most diluted color. Start your gradations with a no. 8–9 in intensity and paint one-third of the rectangle. Then take some of that mixture and add some water to it, painting another third at a no. 5 value. Rinse your brush out and pull down the color with clean water. This should give you a dark, medium and light value of the pigment. Do this with every color; it will enable you to see what each tint looks like. This is an invaluable tool.

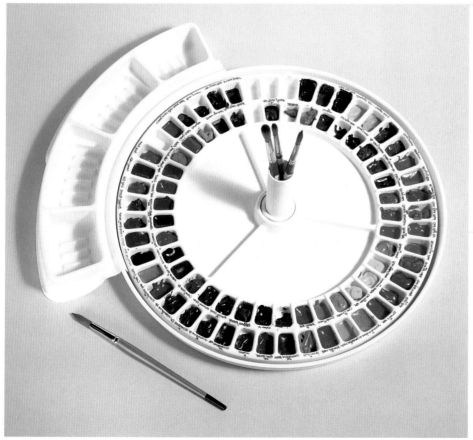

My Palette

A good palette is essential to keep you organized and prepared for painting as well as mixing colors. I love my Spin-a-Color palette because it holds so many great colors and I can see all of them at once. It also has four water wells to keep plenty of clean water.

There are many great palettes available today, and it doesn't matter which one you use as long as it suits your needs. Your palette should hold as many paint colors as you need and have a clean area where you can mix your paint. Select the right palette for your purposes.

Brushes

There are many varieties of brushes on the market. Select one that does the job for you and you are comfortable with. I use the Princeton Round 6300R, nos. 2, 4 and 6. This stiff round bristle brush allows me to immediately pick up the right amount of paint so my colors are intense enough and allows me to push the paint around where I want it. It also lifts color out better than a soft brush.

My other brush is the Princeton Bright 6300B, nos. 2 and 4. This is a flat brush, which lifts, scrubs and pushes the paint. It is excellent for scrubbing out thin lines if you use the chiseled edge at an angle. It is great for lifting subtle gradations or highlights.

For creating washes I use the Princeton Round 4050R, nos. 8, 10 and 12. These can be replaced with other soft brushes such as Cheap Joe's Golden Fleece no. 10, Robert Simmons's Sapphire S85 no. 12 and M. Grumbacher's Golden Edge 4620 nos. 10 and 12.

Visit your local art store and test some brushes. Buy a soft brush for washing and a harder bristle brush for lifting.

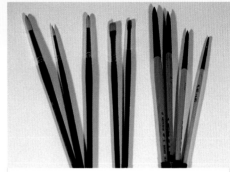

Finding the Right Brush
I like shorter bristles rather than longer ones because I have more control over them—that's just one of the things I look for in a brush. Other things to consider are how much water the brush will hold, how big or small the brush is and how it balances in your hand. As with your pigments, always purchase quality professional brushes.

Brush control is vital to being a painter. Learn to control the tip of the brush very well and there will be no need to use a very small brush when painting small areas or signing your name. Keep a good tip on your brush and learn how to control it. Never use your brushes for anything other than painting with watercolor—especially applying masking fluid. Save your old brushes for other uses.

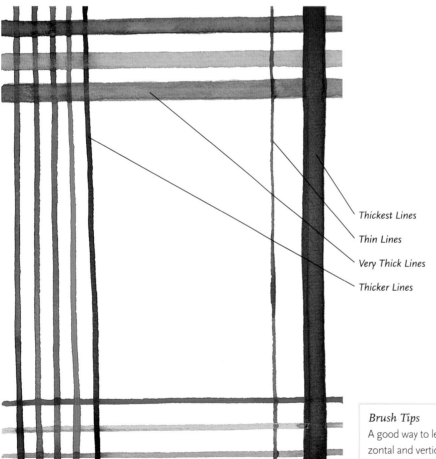

Thickest Lines

Thin Lines

Very Thick Lines

Thicker Lines

Brush Tips
A good way to learn how to control the tip of your brush is to practice horizontal and vertical lines; paint some thick and some thin. Align your strokes with the edge of your paper and try to keep them straight, concentrating on using the tip of the brush.

Paper

I have gone through every type of paper there is! Again, this is a personal preference. Each paper creates a different effect. Paint lays on top of hot-press paper, showing more brushstrokes. Paint lays in the grooves of cold-press paper, giving a smoother finish, and rough paper gives a courser appearance. I like a medium finish, so I use Arches 300-lb. (640gsm) cold-press bright white. I don't like to stretch paper, so the 140-lb. paper won't work for me! I also like vivid colors so I avoid off-white paper. The bright white seems to enhance the colors in my paintings. Also, you can scrub the daylights out of the 300-lb. (640gsm) paper and still not scrub a hole through it. It's a very durable

paper with a soft velvet finish. I use Fabriano Uno 300-lb. (640gsm) cold-press paper when I want a softer look.

I also use Crescent illustration board cold-press, which is a little slick. If I know I am going to enhance the painting with the airbrush, I will work on illustration board. Again this is a personal choice; you can purchase packets of different paper to experiment with from most art supply catalogs. Go on an art paper adventure and try out different types of paper and find what works best for you.

Mounting Your Paper

I use ¼" (6mm) thick foamcore cut 1" (25mm) larger than my sheet of water-

color paper for a mounting board. I take clear packaging tape and tape in about 2" (51mm) around the edges of the foamcore. This keeps the foamcore from peeling off every time you change the paper. You will need a utility knife to cut the foamcore. Make it 1" (25mm) bigger than the size of your paper. This mounting board should last for a long time and is easy to carry around because it is lightweight. I have several sizes for my work.

You will want to tape a border around your paper with artists' tape or drafting tape to secure your paper to your mounting board. Never use masking tape as it can peel the top layer off the paper.

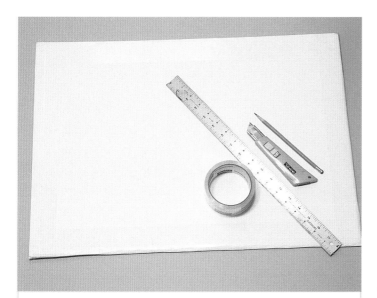

Preparing Your Board
Take a piece of ¼" (6mm) foamcore and cut it 1" (25mm) larger than your sheet of paper. Take some clear packaging tape and tape in 2" (51mm) around the sides. This will allow the board to be reused. If you don't put the packaging tape on the outer edge of the foamcore, the surface can tear when you remove the tape that secures your watercolor paper. This should last through several paintings. I have one for a full sheet 24" x 32" (61cm x 80cm) and a half sheet 24" x 16" (61cm x 41cm). You can cut it any size you prefer, just make sure to leave it 1" (25mm) larger than your painting.

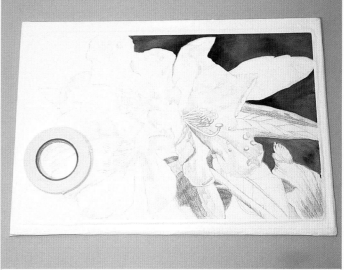

Attaching Your Paper to Your Board
When your foamcore board is finished, take artists' tape or drafting tape and secure your watercolor paper to the board.

Setup

One of the most important aspects to consider when painting is your setup, or work space. I have seen students bend over a painting and leave with a backache at the end of the day. You need a comfortable chair to sit in if you paint sitting down. Your board should be at an angle (a drafting student of mine said 22½ degrees!) so that the paint can flow properly.

Your paper should be securely taped to your foamcore or mounting board so it will not move or slip around. You should be able to move the entire board easily.

Your palette, water container, paper towels, kneaded eraser, pencil and brushes—all your supplies—should all be on your right side (left if you are left-handed). You don't want to drip water or paint across your paper.

You should have adequate lighting, preferably natural light from a north-facing window. I have my drafting desk backed up to a north window, and the constant light is wonderful.

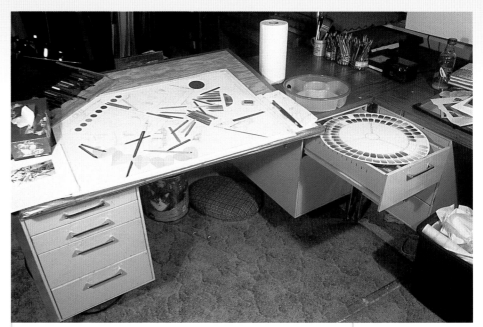

The Setup in My Studio
It is nice to have a place where I can leave everything and come back to it later. If you don't have a studio space, find a quiet place just for you with good lighting. Set up your drafting table, a good chair, foamcore or mounting board, water container, palette, paper towels and brushes just like you see them here. If you keep yourself organized, watercolor won't be frustrating and you'll be happier when painting!

Additional *Supplies*

I use a few other materials when painting. I always keep in mind: "Use whatever it takes to make the painting work."

- Airbrush
- Artists' tape
- Craft knife
- Electric eraser
- Facial tissues
- F&W Acrylic inks (bright concentrated acrylic colors to enhance places in your painting)
- Gold leafing (thin gold paper applied with an adhesive to your paper; the gold leaf paper is applied and brushed off)
- Kneader eraser
- Masking fluid
- Pastels (soft pastels and Nu pastels)
- Pastel pencils
- Pencils
- Prismacolor pencils (colored pencils)

And last but not least the computer and digital camera. When I start a painting, I take a digital photo of the tonal drawing and display it on the computer screen to check my painting for accuracy of the drawing and values. The computer image tells all. The same thing can be done by taking a photo with a regular camera and checking for mistakes; the computer is just quicker. Halfway through I check it again, and again at the end. You can also take the photo you are working from and enhance the colors on the computer to make them more vivid. This helps a great deal if you have a hard time reading color. The computer allows you to analyze your colors and think what pigments will create the color combinations you want. It also enables you to visualize the painting in more vivid, glowing colors, helping you establish a more intense range of color.

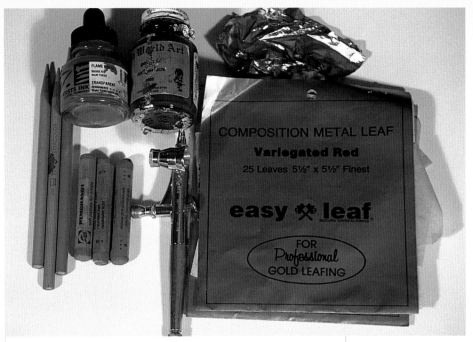

My Extra Little Goodies
I always keep some additional supplies handy because I never know when the painting will need them.

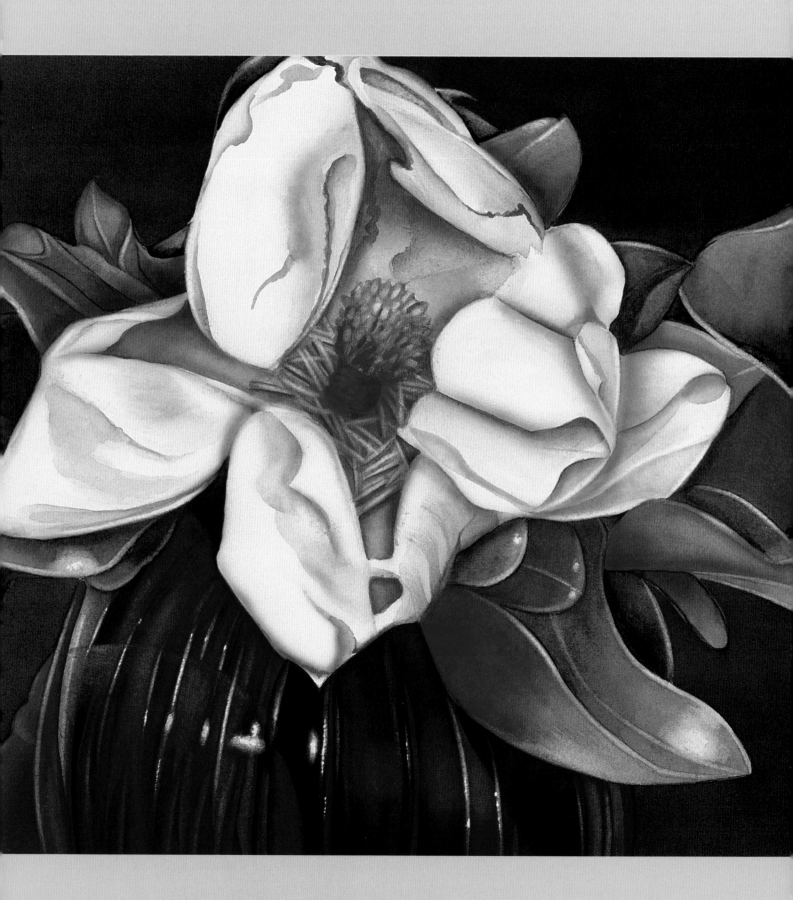

Understanding
Value

Values range from delicate lights to rich, glowing, deep darks. Without the correct values your paintings will be flat, lacking depth and form. Together, value and color make a painting sing.

Artists often say that as long as your values are correct, you can use any color. This statement is so true. Learning to see value will help you see all sorts of color. In this chapter we will explore value and how it will help you start a painting using a three-value drawing. There are many values in any subject or scene that should be included in your painting. But finding the three basic values first will help you analyze the darks, mediums and lights of your painting. We will use a value chart to show how much water to use to create a range of values. This chapter promises to be filled with "value-able" lessons.

Magnolia · *Watercolor on Fabriano Uno 300-lb. (640gsm) cold-press paper* · *15" x 22" (38cm x 56cm)*
Collection of Mary Kay Scholass

Recording *Your Image*

Let's start with the concept of color and contrast, which will help you understand value better. Remember, you should paint something that is interesting and exciting to you. I have a beautiful cobalt blue vase that sits on my dining room table. Every evening the setting sun glows on it. Visually, the color and patterns that are created capture my attention and enhance my imagination. I wanted the perfect flower for the vase. One day I saw a beautiful magnolia tree in bloom outside the gallery where I teach. I put the two elements together in my mind—color and contrast. However, picking the magnolia was a different story—twenty-five feet up!

When I put the magnolia in the cobalt blue vase I was struck by the impact of the colors and contrasts—the richness of the blue vase, the shapes created from the reflected sunlight and the softness of the creamy white magnolia petals—I had to paint this beauty! Can you see the attraction? Don't ever paint anything that doesn't interest you or it will become an unsatisfying chore.

There were several elements to consider before I could begin this painting. I wanted to create wonderful values and enhance the colors. Creating an accurate reference was my first concern.

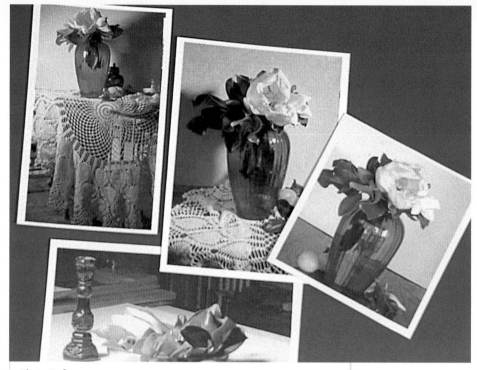

Photo References

Take as many photographs of your subject as possible using different settings and lighting. Compose the shot in the viewfinder of your camera after setting it up. I photograph each composition, studying carefully through the viewfinder and rearranging the props to create a strong composition. For this photo, I waited until the sun was setting to produce long, warm reflective shadows. I photographed the still life in both natural light and in my studio. I photographed several different views all around the subject matter.

Photography

I knew that I could not paint this subject from life because the flower fades quickly. I ran to get my 35mm camera, digital camera and sketchbook. Paint from life whenever you can, as it's a lesson in itself. However, there are some things you can't paint from life. Unfortunately, this was one of them.

The next element to consider is the lighting and light source. You need good light to achieve good values. This still life required the right lighting to capture the fragile beauty of the flower and the dazzling light patterns of the vase. I placed the vase near a window that faces north and photographed it using this natural light (no flash!). I immediately loved what I saw through the viewfinder of the camera. I wanted the best possible composition so I shot several variations of the flower and vase. Some were taken by the window. I then moved the still life to my studio and put it under a spotlight. I shot several more photographs adding different elements, like a teacup, a candlestick and some lemons. I placed each element carefully to create an interesting composition.

I placed the vase and flower by the window and lit it with a spotlight. This time I got just what I wanted. The lighting was

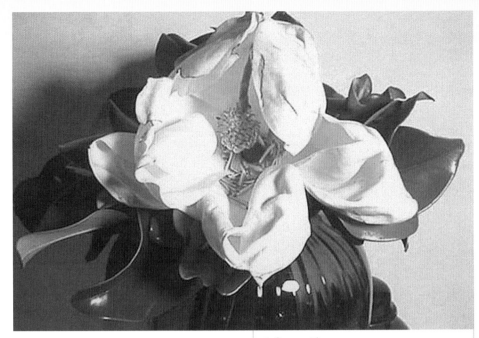

Reference Photo
Select a photograph that captures the shapes, colors and contrast you wish to paint.

soft and beautiful, complimenting the beauty of the flower. The light from the spotlight created beautiful, glowing colors and strong values, just like the sun did in the first shot. I photographed everything from very intricate close-ups of the flower to more complete setups with the other elements. I used my digital camera as well as my 35mm camera to immediately examine and critique the composition. I was eager to validate my first impression regarding this latest pose, a close-up view.

Crop Your *Image*

When I looked at the image of the photo on the computer screen, it was absolutely beautiful, but the vase and flower were fighting for attention. They both wanted to be the star! I printed the composition I liked the best and started to crop it with pieces of paper forming a window around various areas of the photograph so I could determine who would be the star. The result was pleasing and I had a nice composition for the time being. This gave me a good start.

Crop Your Image
Use strips of paper to crop the image, moving them around to design your composition. Use invisible tape (tape that won't damage the photograph) to secure the pieces of paper to the photograph. You now have a good composition to work from. It's fun to experiment—you can crop it or leave a lot of background showing—it all depends on what you want.

Thumbnail *Sketches*

In my sketchbook, I quickly sketched the composition from life and noted all the colors and values I saw. I named the colors according to the ones on my palette so it would be easy to begin the painting. The purple/blue on the left top petal of the magnolia was noted as Winsor Violet and Royal Blue with a touch of Permanent Rose. I abbreviated the names so it was easier for me to read. I call it artistic dictation—W.V. + R.B. + a touch of P.R.

I also made notes on many aspects of the composition: the reflected color on the magnolia petals from the vase; the abstract light shapes on the vase; the way the light hit the magnolia and softened the edges; and the wonderful colors in the shadows of the petals that were reflected from the vase. I jotted down everything I saw because I knew the photograph wouldn't tell me everything I wanted to know. It was very important to see everything and make notes about it, so I could capture the excitement and joy that I felt about the subject!

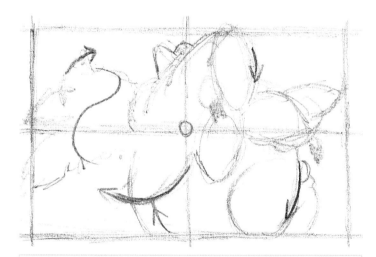

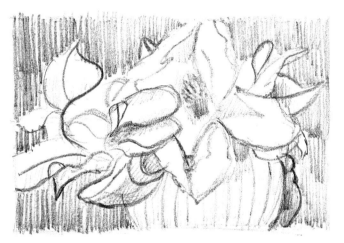

Create Thumbnail Sketches
Draw sketches to record what you see in your still life. The camera will only capture so much. It is important to note color and value contrasts from life. This will record accurate details about your subject and give you the information you need for your painting. Thumbnails reveal the abstract shapes and values so I know that I have a good composition for my painting.

Create a *Value Sketch*

OPAQUE AND SLIDE PROJECTORS

Both opaque and slide projectors allow you to project an image onto a wall or paper, enabling you to trace directly onto your drawing surface. It saves time by allowing you to alter the size of the image and to capture the correct proportions. You can change the size of your drawing by adjusting the distance between the paper and the projector.

Mount your paper on a flat surface, such as a wall or straight easel. Make sure your paper and the projector are parallel to each other. If one is at a slight angle, your image will be distorted. Draw the projected image directly on your paper, tracing the lines, not the shading.

Some artists object to the opaque projector. I think it is OK to use the projector to create a line drawing and check the placement and size of the image.

Do not draw your values using the projector or you will be mindlessly copying. Drawings made entirely from the opaque projector produce distortions and stiff, graphic-looking drawings. Also, you might copy photographic distortions. It helps tremendously to sit down and study the image or actual subject instead of copying it from the projector. After completing your line drawing, study the values, memorize them and add them to your subject.

After all my notes were made, I spent some time analyzing this composition, especially the color. My next step was to create a drawing that revealed what I saw and knew about the subject. Because I was not painting from life, I had to be careful to draw this image correctly. Photographs often distort reality, reading opposite and flat.

After cropping the composition I had a good feel for what it would look like. However, after doing a few thumbnail studies, I realized it was too symmetrical (a good reason to do thumbnails!—see page 25). To correct this I took another photograph and added more leaves to balance the composition using the computer. If you don't have a computer you can take a piece of tracing paper and place it on top of your photograph and draw the elements you need, in this example, the leaves. You can use extra photographs to cut out the elements you need and tape them onto your photograph.

When adjusting my composition I tried to keep in mind the following: what I remembered of the still life; my sketchbook notes about colors and shapes; and the values from my quick sketches.

I start all my paintings with a detailed line drawing on the watercolor paper, but only after I have done the thumbnails and worked out the design. You can enlarge your drawing to the size you want. You can either enlarge it by hand, drawing it at a larger scale, or use a photocopier to enlarge it. If you use a photocopier you can transfer the image using tracing paper.

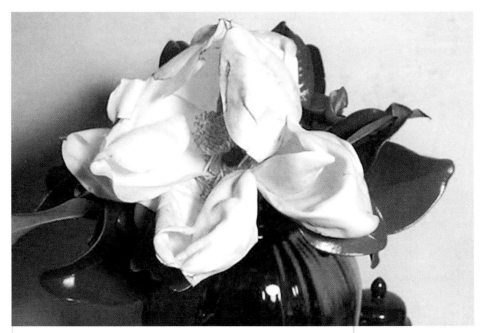

Seeing Values

Squint your eyes when looking at values and shapes. To help you see values you can have your photograph printed in black and white. You may want to have a light and dark version printed. Sometimes the whites can be washed out in photographs, so printing a darker version will help you to see the values in the light areas and vice versa. Just take your negative to your local photography store and tell them what you want and what you are using it for. It's so exciting to say to them, "I'm an artist." You can also do this on the computer by de-saturating your photograph. Or you can look through a red piece of acetate to help you see the values.

Trace the image onto the tracing paper. When you are finished, flip the tracing paper over and use a graphite pencil to trace the image on the backside. Place the tracing paper on top of the watercolor paper and transfer the image onto your watercolor paper. Copy only the lines using a standard or colored pencil, not a pen. Be careful you don't leave any indentations in the paper.

When the line drawing is complete, I block in the dark, middle and light values. I use the white of the paper for my lightest value while focusing on all three values.

Draw the leaves using a no. 2 pencil. Study the nuances of the values from your photograph and sketches. Determine if the values are dark, medium or light. Think about them while you are drawing. At what point is the leaf dark and why? When light strikes the leaf is it medium or light valued?

You want the flower to be the center of interest. So shade the leaves darker so the flower will stand out, even if the contrast on the photograph is not as strong. You want the flower to be lighter, so use lighter values within the flower. The center of the flower is concave and therefore is darker. Shade on the darker side because you will be erasing all of this! While creating your value drawing think about the color and how it relates to the values. Remember, this is fun and exciting. You are creating a three-dimensional object on a one-dimensional surface. It's magical when your values are correct.

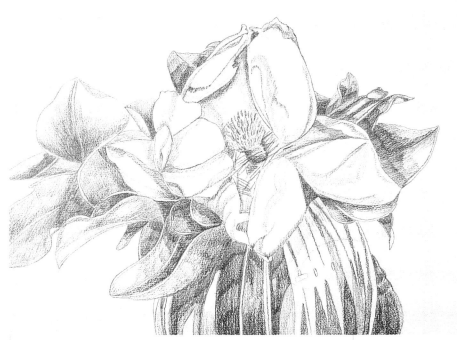

A Detailed Line Drawing
After completing my quick thumbnails I make a line drawing. I draw directly on the watercolor paper using dark and medium values. The lightest value is the white of the paper. I am very careful to rest my hand on a paper towel so the oils from my skin won't transfer to the paper. These oils or dirt will make the watercolor paper resist the pigment.

Create a *Ghost Image*

Once my drawing is complete I erase it to leave a ghost image. Make sure your values are dark enough; if they are too light they will disappear completely, and you will have to keep looking at your photo reference while painting, interrupting the creative process.

This is a wonderful way to paint. You have your drawing on your paper, leaving more time to create and think about glowing colors rather than copying the drawing from the photo while trying to paint.

I know how to draw, this enables me to record what I see. I know that photography distorts images, which is why I sketch images from life in my sketchbook. I remember how I quickly drew my sketch from life and noted the shapes, colors, form and light. I keep all these things in mind while painting.

The Erased Image
When the drawing is complete, I gently erase it with a kneaded eraser. The end result should be a ghost image showing the dark, medium and light values. Remember to maintain your light source.

Value Chart

In chapter 3 we will create a color value chart that will help you recognize the intensity of your colors. But first, it helps to understand how to see values. Take a photograph from a magazine and place a piece of tracing paper over it. Pick out the dark, medium and light values and sketch them on the tracing paper, leaving the light values as the white of the paper. This simplifies values and makes the image easier to understand, especially when you paint a more complicated image. Your final painting will have more than these three values, this is just a beginning.

Value is the most important element in painting. It creates form, shape and a sense of light. You should begin by creating a value chart using Sepia or Payne's Gray to help you understand value. Begin using the lightest value (almost white) for value no. 1 using mostly water and very little pigment. Then paint the darkest value you can, using the least amount of water to create a no. 10. Then fill in the other eight values to create a range going from lightest to darkest.

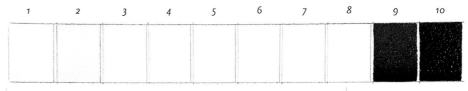

Make a Value Chart

Paint a value chart with squares ranging from nos. 1–10. When you look at things, try to figure out the value number. This is a good way to start if you are unsure of your values. You can place your chart next to the object and compare them. Remember, there will be a range of values in your painting. Start with the darkest dark, value no. 10. Then paint the lightest value, no. 1. Continue down the value scale with the next darkest dark, no. 9, and then do the next lightest value, no. 2. Continue on until all the squares are filled. Study the changes as you go, making sure no two values are alike.

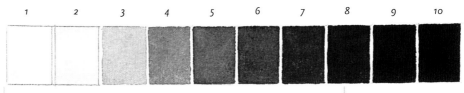

The Completed Value Chart

Your value chart should show a progression of tonal changes. Use the value chart to determine how light or dark a color is or needs to be when you are planning your compositions.

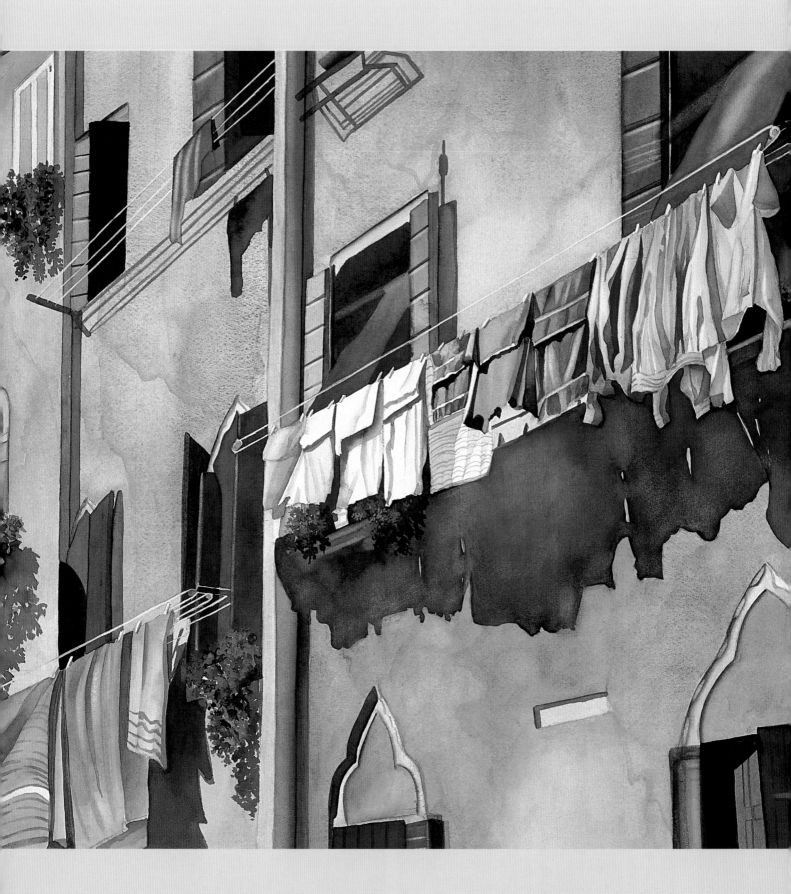

The Personalities
of Color

Color has great impact, and you have the choice to either shout or whisper it. There is softness and serenity to some colors and a bold, dramatic vibrancy to others. Color goes along with value, they walk hand in hand. If your values aren't right, your colors won't be, either.

It is not only important to know your values but it is equally important to know the intensity and personality of each of your colors. This is how you create the soft, subtle washes and the vibrant, dramatic passages. It is imperative to know the difference between the two so you can "shout—be bold" and make the viewer stand up and take notice, or "whisper—be subtle" and create a soft mood for your viewer.

We will discuss the various personalities of the pigments and what they can do for you. These are transparent, opaque and sedimentary pigments. Some pigments do strange, wonderful things. For instance, Daniel Smith's Lunar Earth is a warm, Burnt Sienna-Indian Red color that is very sedimentary and separates right on your palette. It's great for capturing the stucco look of an old building as seen in *Theresa's Italy* where it is mixed with Cobalt Violet and Manganese Blue. It really separates, looking like fine particles of sand on your paper, and is very exciting to work with. Daniel Smith's Southwest Duochrome colors are beautiful sedimentary colors that are reminiscent of the southwestern American landscape. If you know your values and the personalities and intensities of your colors, it will make watercolor much easier. So let's get started!

Theresa's Italy · *Watercolor on Fabriano Uno 300-lb. (640gsm) cold-press paper*
30" x 22" (76cm x 56m) · *Collection of the Artist*

Intensity of *Colors*

Intensity is how concentrated or saturated a color is. Learn the intensity of each of your colors and how far you can push them. More water makes the intensity of the color lighter and paler. Less water makes the intensity of the color stronger and darker.

You can get to know the intensities of your colors by making a numbered value intensity chart. Take all your high-key (light) colors and place them on a chart. Number the chart 1 through 10. The intensity should become darker as the numbers become higher. For instance, Rose Madder Genuine is a light, delicate, high-key color and will only go up to about 4 or 5 on your chart. On the other hand Indigo, Payne's Gray and Winsor Violet are low-key colors and will go up toward 9 or 10. If you number them it will organize your thinking a little better, similar to the value chart.

Winsor Violet
(with more water)

Winsor Violet
(with less water)

How Far Can You Push Your Pigments?
The square on the left is Winsor Violet with a large amount of water. The square on the right is Winsor Violet at its fullest intensity—less water. You can alter the intensity and value of any color by diluting it with water. That is one of the great things about watercolors.

Color Intensity Levels:

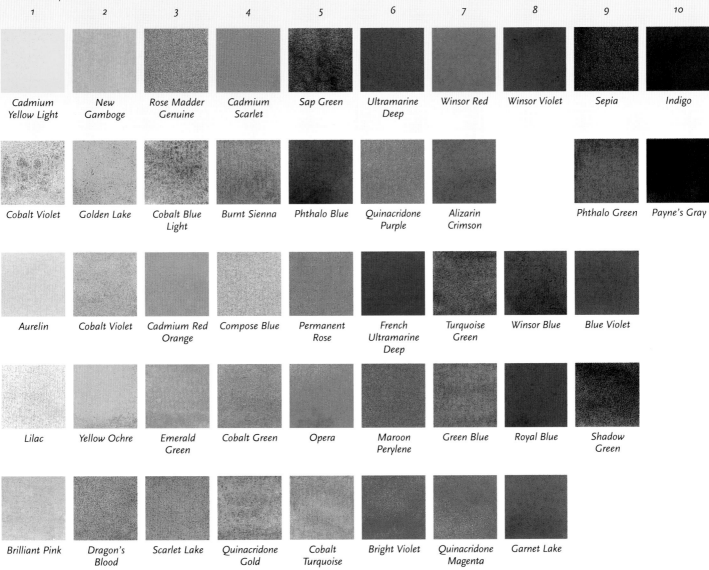

1	2	3	4	5	6	7	8	9	10
Cadmium Yellow Light	New Gamboge	Rose Madder Genuine	Cadmium Scarlet	Sap Green	Ultramarine Deep	Winsor Red	Winsor Violet	Sepia	Indigo
Cobalt Violet	Golden Lake	Cobalt Blue Light	Burnt Sienna	Phthalo Blue	Quinacridone Purple	Alizarin Crimson		Phthalo Green	Payne's Gray
Aurelin	Cobalt Violet	Cadmium Red Orange	Compose Blue	Permanent Rose	French Ultramarine Deep	Turquoise Green	Winsor Blue	Blue Violet	
Lilac	Yellow Ochre	Emerald Green	Cobalt Green	Opera	Maroon Perylene	Green Blue	Royal Blue	Shadow Green	
Brilliant Pink	Dragon's Blood	Scarlet Lake	Quinacridone Gold	Cobalt Turquoise	Bright Violet	Quinacridone Magenta	Garnet Lake		

Color Intensity Chart

Paint a color intensity chart. This will help you to recognize the value for each of your colors and their natural intensities. Now that does not mean that Winsor Violet cannot be a light, soft, high-key color. If you mix more water to this pigment it will be a light, soft purple. The intensity of all colors will be lessened if you add water to them.

Transparent and Sedimentary *Colors*

PRACTICE PAINTING

Take at least a few hours a week to practice painting and learn about your paints and painting. After all, art is 10 percent inspiration, 10 percent perspiration and 80 percent education.

❧

Part of knowing your color personalities is knowing whether your colors are transparent or sedimentary. Transparent pigments can be layered or glazed so you see the underlying color or the white of the paper through the dried pigment. This is one of the beautiful features of watercolors. Sedimentary pigments have particles in the pigment and look like a light dusting of sand to a very heavy granular effect.

*New Gamboge
(Transparent)*

*French
Ultramarine Blue
(Sedimentary)*

*Daniel Smith's
Lunar Earth
(Very Sedimentary)*

Sedimentary Pigments

Sedimentary pigments can be very useful, depending on what you are painting. For instance, beach scenes, landscapes and weathered barns all lend themselves to the use of sedimentary colors. However, if you think of painting a portrait and lay in Cobalt Violet and Lunar Earth—both very sedimentary colors—on the cheek area of a beautiful woman, it may look as though your subject has the chicken pox. This is a good scenario for you to remember what sedimentary colors can do.

Transparent Pigments

In *Renaissance Man*, I've used only transparent colors to glaze the shadows on his face. The underlying colors glow through and still present places on his face in shadow.

Renaissance Man · *Watercolor on Arches 300-lb. (640) cold-press paper · 22 x 30" (56cm x 76cm)*

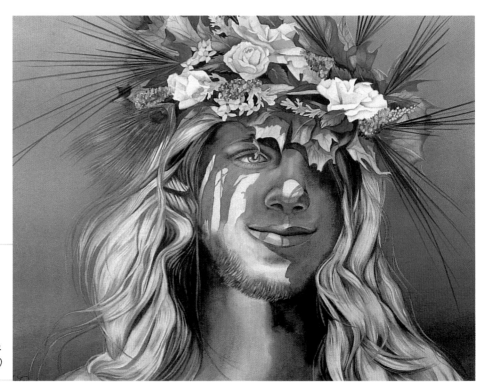

Opaque vs. Transparent *Colors*

WATER CHANGES OPACITY

Remember, you can make any color transparent by adding more water and can keep any color opaque by adding less water. The more pigments you experiment with, the more you will learn about your colors and their personalities.

❧

I have a different view than most artists when it comes to opaque and transparent colors. You can make an opaque color transparent by adding more water to it and a transparent color more opaque by using less water to it. A color is opaque if the pigment floats on top of your water and is a little chalky-looking. Most transparent colors diffuse into the water.

Non-staining, opaque colors will lift out easily, while staining colors must be scrubbed out. That's not to say you can't remove staining colors if you use the proper brush to lift them without damaging your paper. A good test to see if your pigments are transparent, opaque or staining is to take a permanent (not water-based) black felt-tip marker and draw a 1" (25mm) line horizontally across a piece of your favorite watercolor paper. Paint a vertical strip of each of your colors using a number 5 value. Opaque colors will cover or stand up on the black line. The black line will show through the transparent colors. Check the color charts provided by manufacturers to see what the qualities of your pigments are. They will list whether they are staining, non-staining, transparent or opaque.

After your strip of colors is dry, take a bristle brush and gently try to lift out each color on one side of the chart. You will not be able to lift out the staining colors but will be able to easily lift out the non-staining colors.

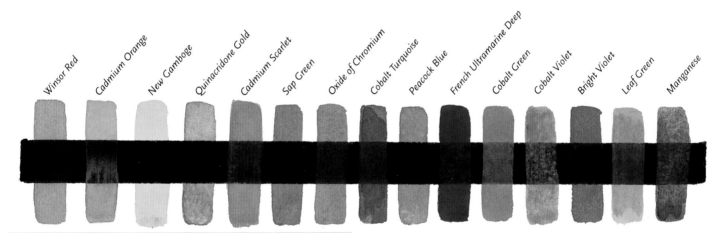

Opaque vs. Transparent
Take a black permanent felt-tip marker and draw a line horizontally across your favorite watercolor paper. Take each of your pigments and paint a strip of color vertically with a number 5 value. If the color sits on top, it's opaque. If the line shows through, it's transparent. Keep this chart handy until you memorize your colors and their properties.

Complementary *Colors*

KNOW YOUR COLORS

Be careful when reading color names, they can be tricky. French Ultramarine Blue and Ultramarine have similar names but are different colors. However, New Gamboge and Gamboge are not as different. The only way to see how one manufacturer differs from the others is to study color charts and actually paint with the colors and compare them. You can decide which ones you like best. Eventually, you will memorize them, and that's where the fun begins!

Now the fun begins. You should know your primary colors and their secondary complements. The primary colors are red, yellow and blue. The secondary colors are green, orange and purple. Mixing two primaries that are next to one another on the color wheel will create secondary colors. Mixing blue and yellow creates green; mixing yellow and red creates orange; and mixing red and blue creates purple.

The complementary colors appear opposite one another on the color wheel. The complement of red is green, of blue is orange and of yellow is purple. Of course there are many tube colors to choose from, so just remember the basic complements.

A good way to memorize them is red and green are Christmas colors, yellow and purple are Easter colors, and blue and orange are a beautiful sunset. This is the way I memorized them in school, and it still works! It may seem like you will never memorize all these things, but if you keep painting, pretty soon it will become automatic to you. You'll see!

One other thing to remember is that when you mix complementary colors you will create a neutral. For example, if you use a wash of Winsor Blue and glaze over it with Cadmium Orange, you will create a neutral color. Neutral colors (grays and browns) are made from mixing complements together or glazing them on top of one another. We want to have exciting glowing colors so we will avoid mixing neutrals for the most part.

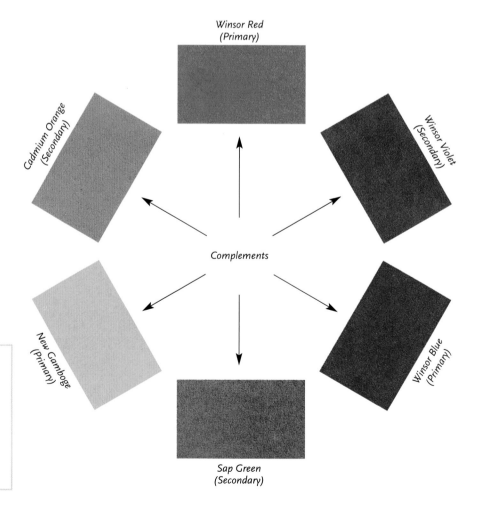

The Color Wheel
The color wheel will help you remember how colors interact. This example shows you which colors are primary colors—red, blue and yellow—and which are secondary colors—green, orange and purple. It also shows you which colors are complementary colors—red and green, blue and orange, and yellow and purple.

Black and Neutral *Colors*

A LITTLE WARNING

Watch out for hot spots in your painting. Hot spots are formed when too much pigment and not enough water is used. When the pigment dries there will be small shiny spots on the paper. This is pushing your pigment too far, which is not becoming to your painting and is very distracting.

❧

I don't have any neutral tints or blacks on my palette. If I want black, I first decide if I want it to be cool or warm, then mix it accordingly.

You can mix very beautiful blacks by using a combination of primary colors. For a luscious, warm black use Winsor Red, Indigo and some Indian Yellow. For a cooler black use Indigo, Alizarin Crimson and a little New Gamboge. There are dozens of formulas for mixing black. Try your own using some intensifying colors such as Phthalo Green, Phthalo Blue, Indigo, Prussian Blue, Hooker's Green, Winsor Violet and other colors that are strong in intensity.

THE BASICS OF COLOR

Because I work with so many different colors, it is imperative to create the color topper discussed in chapter one. I make an effort to memorize my colors and what they will accomplish for me. There are things that you should memorize or write down to help you understand your colors. Try to associate the colors you see with the names of the colors in your palette. This will help you recognize color immediately.

❧

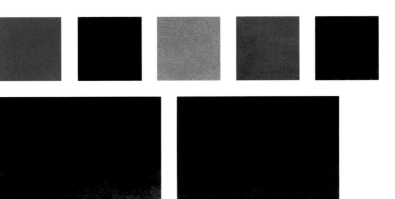

Mixing Blacks

I like to mix primary colors to create my blacks. That way I can create the right black for each painting. I never know if I will need my black to be warm or cool so I mix them as I go. I never use black from a tube.

Color *Temperatures*

I once saw a movie about a blind girl who didn't understand what color was. To explain color, her teacher took an ice cube and placed it in the girl's hand and told her it was cool. When things are cool their colors are blues, blue-purples, and cool blue-greens, violets, etc. Then she placed something hot in her hand for the warm colors, yellows, yellow-greens, reds, oranges, etc. This is a good analogy for color temperatures. We are so blessed to be able to see all the rich colors around us. Look at them and relate what you see to the name of the color in your palette. This will help you really see color.

Understanding color temperature is one of the most important parts of painting. You should learn to recognize the temperature of every color. A good way to start is to compare colors against each other. Paint a small strip of French Ultramarine Blue, the coolest color. Look for the blue in the French Ultramarine. Now paint a strip of Cobalt Turquoise next to the French Ultramarine Blue and look for the yellow in the Cobalt Turquoise. You have to look into the color. Now paint a strip of Alizarin Crimson and Winsor Red next to each other. Look into the crimson to see the blue in it. Look into the Winsor Red and see the yellow in it. By comparing

them to one another you will be able to see the color better. Learning to do this and memorizing it will help you produce paintings with balanced color temperatures. Often artists paint beautiful paintings that are all cool with no warm relief or all warm with no cool relief. It's good to have temperature variations in your work. You should avoid 100 percent warm paintings or 100 percent cool paintings.

The circles below are good examples of how to distribute your color temperatures. If you think of this while painting, it will help you remember to have the correct balance in your paintings, thus avoiding an all-too-hot or all-too-cool painting.

A Cool Painting
This circle is predominantly a cool, dark painting. The color temperatures are 25 percent warm lights and 75 percent cool darks.

A Warmer Alternative
This circle has a warm color scheme or a warm dominance. The temperature composition is 25 percent cool lights and 75 percent warm darks.

It is very important to balance your color temperatures in your paintings. Try not to have a 50/50 balance of color temperatures. If you use the 25/75 percent theory, it will help you to remember to balance the color temperatures as well as the lights and darks.

Be aware of middle-value paintings. It's so easy to wind up with a middle-value painting. Try not to create a painting with equal values throughout. Try some different color combinations using this theory. You will be amazed how balanced your work will become. Concentrate on painting the lights a light value and the darks a dark value, but with different colors.

Observe what the temperature of the lighting is, too. Morning light is cool while afternoon light is warm with its oranges and pinks cast from the setting sun. As long as you have a variety of temperatures and values in your painting, it will stay interesting to the viewer.

Warm vs. Cool

Try this fun assignment and make a temperature chart for all your colors. Put all the warm colors in the one category and all the cool colors in another. Label them by color and manufacturer. Now, look for the blue in colors for the cool and the yellow in colors for the warms. Check out this example. In the top square I painted French Ultramarine Blue, the coldest blue. In the bottom square is Cobalt Turquoise, which is a warm blue. Can you see the yellow in the bottom square?

Balancing Color Temperatures

In *Sixties* you can see how I utilized 25 percent cool lights and 75 percent warm darks, a nice balance of color temperature. Starting from the front of the face, the cool lights go from French Ultramarine Blue to Alizarin Crimson to Mauve. Then it moves into the warm darks: Winsor Red to Sap Green to Warm Sepia mixed with Cadmium Scarlet to Winsor Red mixed with Warm Sepia—a very dark, rich and warm color. Even the scarf on the head goes from a cool blue to a warm rich blue in the back. The painting is not an all warm or all cool painting. It has a very nice color temperature balance. twenty-five percent cool lights and seventy-five percent warm darks.

Sixties · *Watercolor on Arches 300-lb. (640gsm) cold-press paper · 30" x 22" (76cm x 56cm)*

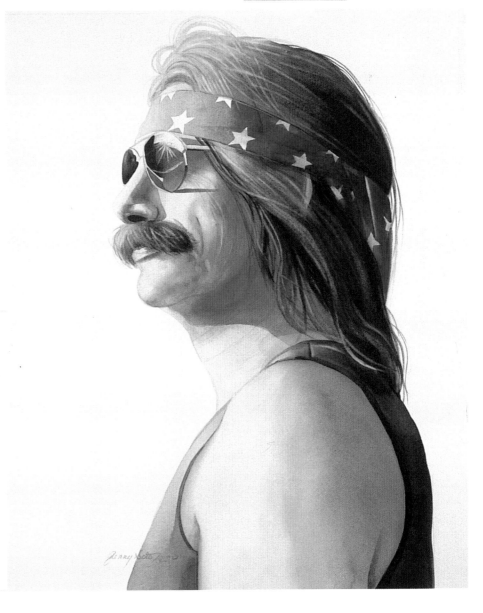

Organize *Your Colors*

Everyone sees color differently. These are examples of the way I see color and a guide to read color for the beginning student or artist who has trouble seeing color. If you recognize warm and cool color temperatures, you can associate them with your pigments. It is much easier to paint and apply the right percentage of color to your work for a well-balanced painting.

My color chart lists all the colors I keep on my palette or use in this book by manufacturer. It will tell you if a color is warm or cool, transparent or opaque. Use this chart to help you get started. You should purchase a warm and cool hue for each of the primary and secondary colors. You may also want to purchase a few good neutrals to add to your palette.

Palette Color
This chart will enable you to see all the shades of the color and to recognize its personality. You should make your own chart that shows a gradation of each color. Mark on your chart whether it is sedimentary or transparent, warm or cool and the manufacturer.

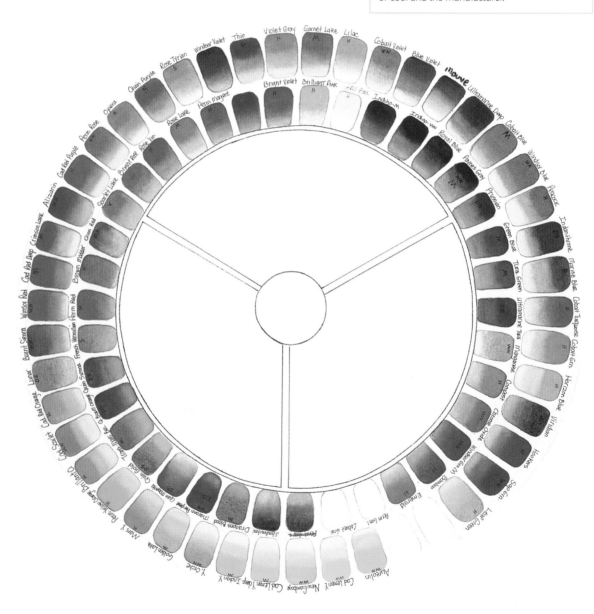

Daniel Smith (DS)

Indanthrone Blue	cool	transparent
Lunar Earth	warm	opaque
Perinone Orange	warm	transparent
Phthalo Blue	warm	transparent
Phthalo Green	cool	transparent
Quinacridone Burnt Orange	warm	transparent
Quinacridone Burnt Sienna	warm	transparent
Quinacridone Magenta	warm	transparent
Quinacridone Red	warm	transparent
Quinacridone Sienna	warm	transparent
Ultramarine Turquoise	cool	transparent

MaimeriBlu (MB)

Avignon Orange	warm	transparent
Cadmium Orange	warm	opaque
Cadmium Yellow Deep	warm	opaque
Cadmium Yellow Light	warm	opaque
Cobalt Blue Light	warm	transparent
Crimson Lake	warm	transparent
Dragon's Blood	warm	transparent
Garnet Lake	cool	transparent
Golden Lake	warm	transparent
Green Blue	warm	transparent
Indigo	warm	transparent
Permanent Violet (Blue)	cool	transparent
Primary Blue	warm	transparent
Rose Lake	cool	transparent
Transparent Mars Brown	warm	transparent
Turquoise Green	warm	transparent
Ultramarine Deep	cool	transparent

Holbein (HB)

Bamboo Green	warm	transparent
Bright Rose	cool	transparent
Bright Violet	cool	transparent
Brilliant Orange	warm	transparent
Brilliant Pink	warm	transparent
Brown Madder	warm	transparent
Cadmium Red Deep	warm	opaque
Cadmium Red Orange	warm	opaque
Cadmium Red Purple	cool	opaque
Cadmium Yellow Orange	warm	opaque
Cobalt Green	warm	opaque
Cobalt Turquoise	warm	opaque
Compose Blue	warm	transparent
Emerald Green	warm	opaque
Horizon Blue	warm	opaque
Leaf Green	warm	transparent
Lilac	warm	opaque
Manganese Blue	warm	transparent
Marine Blue	warm	transparent
Mars Yellow	warm	transparent
Opera	cool	transparent
Peacock Blue	warm	transparent
Permanent Magenta	warm	transparent
Permanent Red	warm	transparent
Permanent Yellow Orange	warm	transparent
Rose Violet	cool	transparent
Royal Blue	cool	transparent
Shadow Green	neutral	transparent
Shell Pink	warm	opaque
Violet Grey	cool	opaque

Grumbacher (GR)

Thio Violet	warm	transparent

Sennelier (SN)

Blue Violet	cool	transparent
French Vermilion	warm	transparent
Quinacridone Purple	cool	transparent
Tyrian Rose	cool	transparent

Winsor & Newton (WN)

Alizarin Crimson	cool	transparent
Aureolin	cool	transparent
Burnt Sienna	warm	transparent
Cadmium Lemon	cool	opaque
Cadmium Scarlet	warm	transparent
Cobalt Violet	warm	transparent
French Ultramarine Blue	cool	transparent
Hooker's Green	warm	transparent
Indian Yellow	warm	transparent
Indigo	warm	transparent
Mauve (discontinued)	cool	transparent
New Gamboge	warm	transparent
Oxide of Chromium	warm	opaque
Payne's Gray	cool	transparent
Permanent Rose	cool	transparent
Perylene Maroon	warm	transparent
Prussian Blue	warm	transparent
Quinacridone Gold	warm	transparent
Rose Madder Genuine	warm	transparent
Sap Green	warm	transparent
Scarlet Lake	warm	transparent
Sepia	neutral	transparent
Viridian	cool	transparent
Warm Sepia	warm	transparent
Winsor Blue	cool	transparent
Winsor Green	warm	transparent
Winsor Red	warm	transparent
Winsor Violet	warm	transparent
Yellow Ochre	warm	transparent

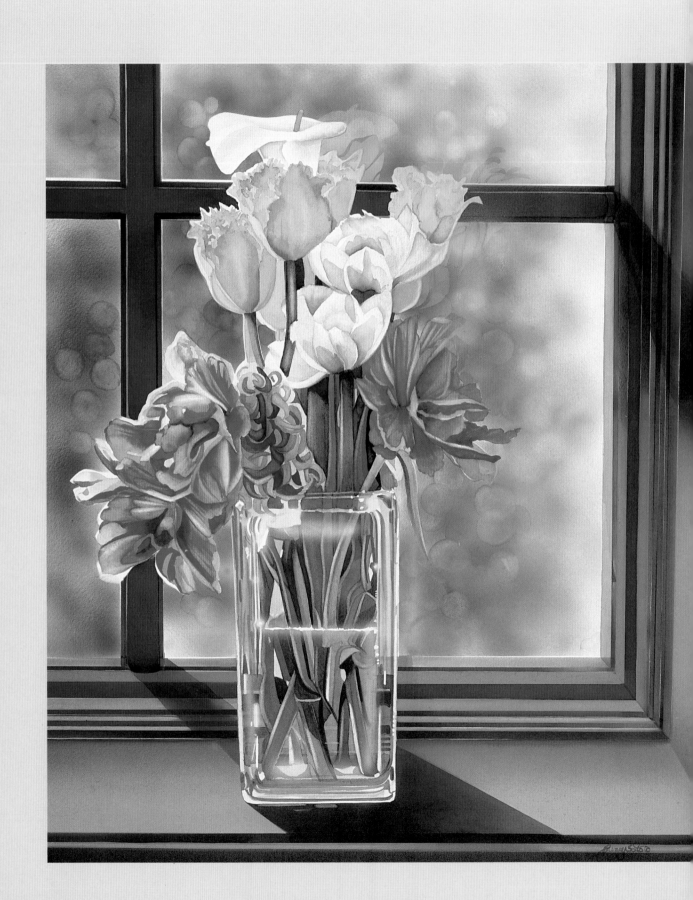

Controlling
Color

Color is the reason I paint. A vivid imagination, along with the knowledge of color temperatures and what they can do, will help you immensely in your work. It's a must to know the properties of your colors. One way to gain control of a color and what it can do for you is to get your watercolor techniques down pat. So, let's start with a few "must-know" techniques. The most important thing you should learn is the direct flat field wash technique. You will utilize this information somewhere in all your work. Whether you paint spontaneously or realistically, you must know how to control the color!

Spring Bouquet · *Watercolor on Fabriano Uno 300-lb. (640gsm) cold-press paper*
22" x 30" (56cm x 76cm)

The *Wash*

KEEP THE BEAD

Remember, you are trying to create a bead of paint and keep the line wet. If you try to pick up too much paint and go more than 4" (10cm), you won't get that bead. You won't get lines in your painting as long as there is a wet bead, the paint doesn't dry and you use light pressure. This will produce a smooth, clean, clear wash as the paint flows down evenly.

In almost every watercolor book, the flat field wash technique is taught. This is the most basic watercolor technique, but each artist does it differently. Here's my version taught to me by Mark Adams, a master of the flat wash. I learned it years ago and almost every one of my paintings uses this technique in some form.

We want the wash to look as though it is airbrushed—very smooth without any lines or *watermarks*. Watermarks are blossoms of water that push the pigment away from an area and leave a flower-like stain. Believe it or not, with practice, you can control watermarks.

I layer many flat washes to get a rich variety of color. That is how I create colors that glow. You can layer colors on top of each other to create new colors. You can mix colors on the palette, but those are flat looking and don't glow. You need to know the flat field wash to begin making glowing colors. We will start with just a plain wash, one value top to bottom.

Winsor Violet Permanent Rose Winsor Blue

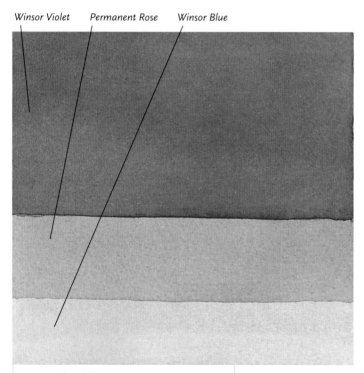

Layers That Glow
Notice the three colors I used for this glaze—Winsor Blue, Permanent Rose and Winsor Violet. Each layer in the example is very smooth with no lines. Learning this technique takes practice, so be patient.

Layers That Don't Glow
There is a difference between glazing and mixing on the palette. This example has all three colors mixed on the palette and applied as a flat field wash. Mix the three colors on your palette and notice the difference between glazing layers of color and applying one wash of mixed colors.

The Flat Field Wash

■ Start with clean water and clean paints. Mix a puddle of a value no. 3 wash using any transparent color. Winsor Blue is a good color to use for this exercise. You don't want to use a sedimentary color because it will show all the uneven sediments and will not glaze as well. Mix enough paint to cover a 6" × 6" (15cm × 15cm) square. Set your drawing board on a slight angle as discussed in chapter one.

Palette

Permanent Rose ◆ Winsor Blue

Winsor Violet

1 The First Wash

Draw a 6" × 6" (15cm × 15cm) square on Arches 300-lb. (640gsm) cold-press paper. Don't use masking tape to tape off the area, as it will cause a bleed back from the tape. Use your pencil line as a guide.

Mix a no. 3 value of Winsor Blue on your palette. Use a no. 12 soft round to pick up the Winsor Blue. Slide the brush horizontally across the paper to form a bead of color, then overlap and continue down the paper until you reach the bottom of the square. Pick up any excess paint using a damp, almost dry brush. Allow the wash to dry thoroughly.

2 The Second Wash

Mix a puddle of Permanent Rose, value no. 3 on your palette. Dip your clean brush into the puddle mixture. Start at the top using very light pressure on your brush; it should move as if it were floating across the paper. Paint about 2" (5cm) across, then pick up some more paint. Don't dry your brush on your paper towels or rinse it out, just go from the paper to the paint and back to the paper. Continue sliding your brush horizontally across the paper, stopping every 2" (5cm) to load more paint. When you come to the end, slide your brush down and over in the opposite direction. Keep the brush moving horizontally. It will drip down if you paint vertically. Allow the wash to dry thoroughly.

3 The Third Wash

Mix a puddle of Winsor Violet, no. 3 value. Pick up the Winsor Violet and begin painting, overlapping a little each time you start a new line. Remember to use very light pressure as you did in step two. You have to build up the washes to make them glow. This takes time and lots of glazing.

When you get to the bottom, squeeze out your brush with your fingers and pick up the excess paint. Dry the paper with a hair dryer or allow it to dry by itself. Always make sure the paper is dry before adding the next glaze.

The Flat Field Wash Within a Painting

PRACTICE YOUR COLOR SCHEMES

Create different color schemes for your art. A red rose in a glass? What color would your background be? A bright green? A warm green? A cool green? Try different combinations. If you have trouble visualizing this, go and buy some different colors of mat board from your local framer or art supply store. Set them up and photograph them or paint them from life. Try to paint the color you see by glazing. It's a great lesson and will help you learn both the wash technique and your color personalities.

❧

Palette

Payne's Gray ◆ Winsor Blue ◆ Sap Green

Let's use the flat field wash in a painting. Here's a step-by-step demonstration of what we have learned so far applied to a painting. I liked these particular flowers because they are bold and bright. In addition to their beautiful color, they are the state flower of my native California—the poppy. I wanted a complementary background in the painting to make it "pop."

I picked a few of these poppies and noted the colors, the temperatures, the shapes and the values in my sketchbook. It would have been great to paint these flowers from life, but the photograph had to do. I then picked out the complementary colors of the orange flowers. The flowers are yellow-orange-red but mostly orange, so I picked a blue-green for the background, which makes the flowers stand out. Sometimes a background can take over your whole painting if it is not properly thought out. I wanted to keep it simple for this painting. Once the color scheme is figured out, you can begin your wash!

Reference Sketch

1 Create Your Composition
Lightly sketch the outline using the photograph and sketchbook as references. Place your hand on a paper towel to keep your paper clean. After the flat wash, you can then draw in the rest of the subject matter.

2 The First Wash

Mix a puddle of Payne's Gray, value no. 3, on your palette. Apply a direct flat field wash of this mixture around the subject matter (the poppies and glass). Add more water to the puddle when you are three-fourths of the way down the paper. Your bottom one-fourth should be lighter in value. Dry thoroughly.

3 The Second Wash

Mix a puddle of Winsor Blue, no. 3 value. Carefully glaze the blue over the dried Payne's Gray.

4 The Third Wash

Mix a puddle of Sap Green, no. 3 value, and glaze it over the dried colors. Keep building on this until you get the intensity you like. I applied eight glazes of the same colors. What a glow!

The Final Painting

To finish this painting I drew in the three values and erased my drawing so that I had a ghost image. I carefully painted the rest of the image with intense colors, concentrating mostly on the shapes and values. I softened the edges with a flat brush, added the shadow, made a few corrections and was finished.

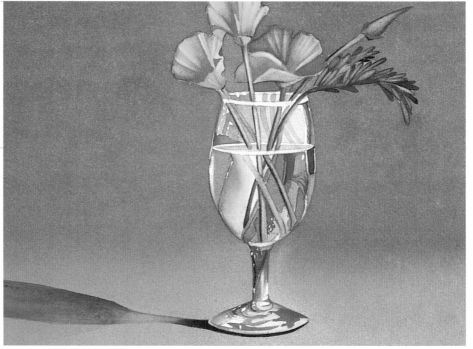

Blending Colors on the Paper

Often you will blend colors on the paper. This subtle blending gives your paintings more value and color variations. It is as easy as painting the flat field wash. You just paint two flat washes and then bring them together and let the colors mix using a little water.

Palette

Winsor Red ♦ Sap Green

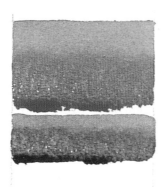

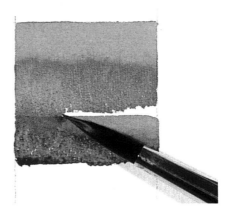

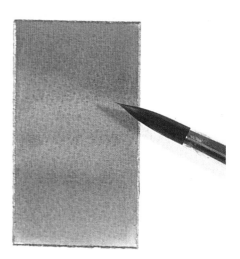

1 Paint Both Colors

Be careful when placing two complementary colors next to each other; gradate them in a fashion so they will not muddy or cancel each other out. Start with Winsor Red and paint a small square.

Leave a small space, then paint a line of Sap Green. Rinse out your brush and squeeze it to remove any excess paint or water.

2 Blend the Colors

Now lightly blend the two colors together using very light, short streaks. This way each color stays true and you don't drag the red all the way into the green or the green into the red.

3 Continue to Blend the Colors

Continue to blend the two colors, moving horizontally across the paper. Pull the Sap Green down the paper using the wash technique.

Variations of the *Flat Field Wash*

There are several different types of washes you can paint. These examples show just some of the washes that are very useful in watercolor painting.

A Gradation of Color

Start with any transparent color. I used Winsor Violet, no. 3 value, and painted the wash all the way down to the bottom and let it dry. Next I mixed a little more color into the puddle, making it about a no. 4 or 5 value. I painted about one-third of the way down and rinsed my brush in clean water. Then I picked up clean water and overlapped the bead. I used the plain water to pull the color the rest of the way down. After it was dry I repeated the wash process until I got the value and gradation I wanted. I was careful to use clean water for the last two-thirds of the wash.

The Color-to-Color Technique

The key to this wash is to make sure that the glazes following the first one are lighter in value. I mixed up three separate puddles in a value range of 3 or 4—New Gamboge, Cadmium Scarlet and Permanent Rose. I applied a bead of New Gamboge one-third of the way down the paper. Then, I rinsed out my brush and picked up the Cadmium Scarlet. If the value is too dark it will create a line, so make sure it is a little lighter than the New Gamboge.

I rinsed my brush again and picked up the Cadmium Scarlet to get the true color and repainted the middle one-third. When overlapping, you are essentially mixing the yellow with the orange. So if you bring it down a little, then rinse out your brush and pick up clean pure color, it will read Cadmium Scarlet. I continued the process with Permanent Rose.

Using More Than One Color

This is a variation of the color-to-color technique. This example mixes purple with red with orange for a different effect. Try several different colors after you have become proficient with the wash. Then put the technique to use on your work. Paint different colors in flower petals, water, sky, landscapes, etc. There are tons of things to paint with this technique; it can be used in small areas as well as large.

The Color Temperature Wash—Cool to Warm

I mixed Royal Blue for my cool transparent color and Winsor Violet for my warm transparent color. I painted halfway down the paper with Royal Blue. Without rinsing my brush, I pulled a little Winsor Violet away from the puddle. I then added a little water and overlapped the bead of color. I rinsed out my brush and went into the Winsor Violet and painted the wash to the end.

This wash can be very exciting in a painting. Practice it on sunsets—cool blue skies with warm pink horizons, or in other backgrounds. You can even use it on subject matter. There are tons of ways to use a change of color temperature wash. It is a good idea to paint small samples of these. This helps you learn your color temperatures and gives you a chance to practice washes so you can control the color!

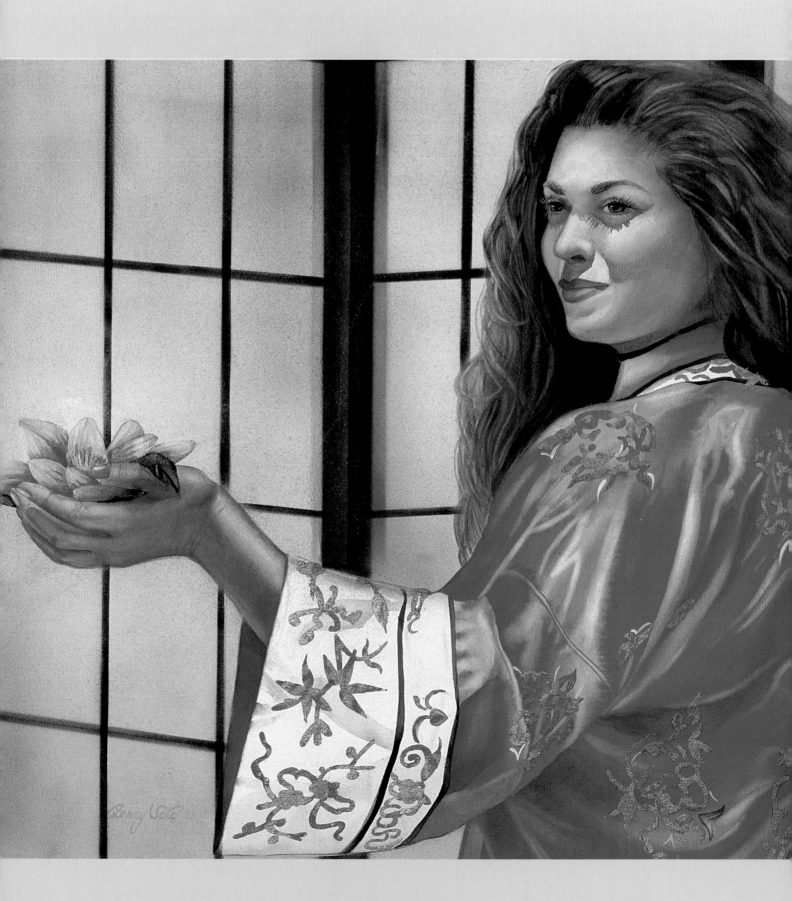

Learning to Underpaint
and Overpaint

Once you know your colors and what they can do, watercolor painting becomes exciting! If you think of your colors as layers of see-through silk, you can get a better idea of how this process will work. Imagine a bright yellow piece of silk held up against the light. In your mind, place a bright orange piece in front of it. Can you see the beautiful, intense warm yellow-orange? This is how underpainting and overpainting works. It also helps you look through objects to see a wide variety of colors and exaggerate them. Once you get the hang of it, a whole world of color will open up for you. You will see colors you didn't even know existed. I think the greatest part of being an artist is color. Could you imagine just painting in black and white all the time? Color is the reason I paint, and I like to exaggerate my colors.

One of my students came to me with a very timid color palette when she first began painting. Her watercolors were pale and wishy-washy. When she began to recognize color, she couldn't wait to come to class every week. And what was more gratifying for me was to see how excited and pleased she was with her work. She is now known for her vivid animal paintings. They are fantastic! So, let's begin with underpainting and overpainting.

Welcome · *Watercolor on Arches 300-lb. (640gsm) cold-press paper* · *22" x 30" (56cm x 76cm)*

Underpainting and Overpainting Bell Peppers

Palette

Alizarin Crimson ◆ Blue Violet ◆ Burnt Sienna ◆ Cadmium Red Orange ◆ Cadmium Scarlet ◆ Cobalt Turquoise ◆ French Ultramarine Blue ◆ New Gamboge ◆ Opera ◆ Peacock Blue ◆ Permanent Rose ◆ Quinacridone Purple ◆ Royal Blue ◆ Sap Green ◆ Winsor Red

■ This demonstration starts with a three value drawing directly on the watercolor paper, which is then gently erased. Of course we set this still life up first, made a preliminary study and took some color notes. When looking at the peppers, look into the natural color and exaggerate it. First look for the color temperature and then look for the highest intensity of the color.

Reference Photograph

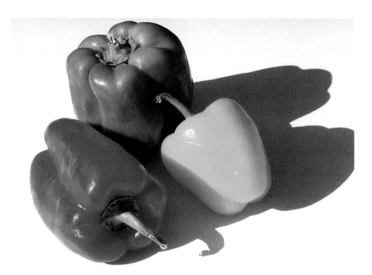

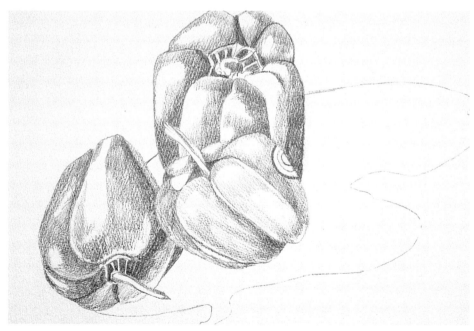

1 Create Your Value Drawing
Compose your value drawing directly on the watercolor paper using thumbnail sketches and the photograph as references.

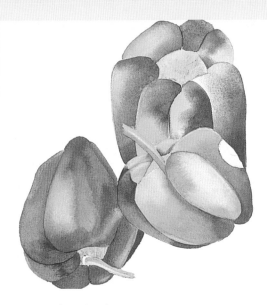

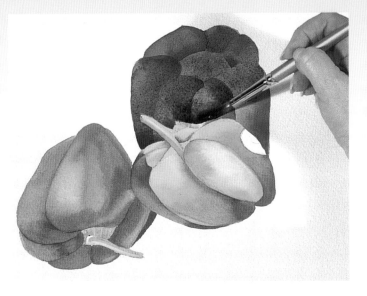

2 Underpaint the Peppers

Begin your underpainting with the red pepper. In the warm areas use Cadmium Red Orange, New Gamboge and Permanent Rose mixed with Cadmium Scarlet. In the cool areas use Alizarin Crimson, Quinacridone Purple and French Ultramarine Blue.

Now look at the green pepper for the color temperature. In the warm areas use New Gamboge, Cobalt Turquoise, Peacock Blue, Burnt Sienna and Winsor Red. In the cool areas use French Ultramarine Blue, Alizarin Crimson, Permanent Rose and Blue Violet.

In the yellow pepper, the warm underpainting is Cadmium Red Orange, Burnt Sienna and Winsor Red. The cool areas are Opera and Alizarin Crimson. Use a light to medium value range. Be careful when placing one complementary color next to another.

3 Overpaint the Green Pepper

Your next step is the overpainting. Start with the green pepper by mixing up a cool green (Sap Green mixed with French Ultramarine Blue or Royal Blue) and a warm green (Sap Green mixed with New Gamboge). Remember, you don't have to use these colors—you can mix your own greens or use another—just be sure that it is the right temperature.

Use a soft brush to glaze over your underpainting, keeping the warms where they belong and the cools where they belong. Be careful with the complementary colors so you don't make mud or a neutralized color.

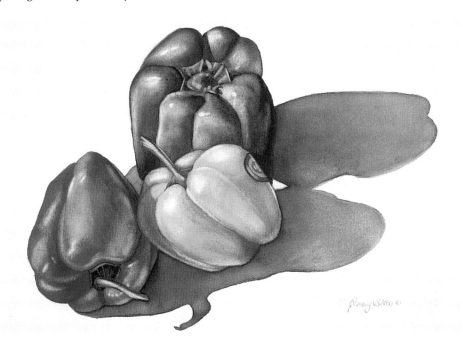

4 Overpaint the Red Pepper and the Yellow Pepper

Glaze over the red pepper. For the warm red use Winsor Red and Cadmium Red Orange. Use Quinacridone Purple and Alizarin Crimson for your cool red.

Move onto the yellow pepper using New Gamboge and Cadmium Scarlet for the warms and a light value of Opera for the cools.

When you have finished overpainting the peppers, gently lift out highlights using a flat scrub brush. Try not to lift out to the white of the paper, as you want some of the underpainting to show through. Add the details and check to see if things are formed and the values are right. If not, mix a dark-colored glaze and add a darker value to give it some form.

Underpainting and Overpainting Roses

Palette

Alizarin Crimson ◆ Blue Violet ◆ Bright Violet ◆

Brilliant Pink ◆ Burnt Sienna ◆

Cadmium Orange ◆ Cadmium Red Orange ◆

Cadmium Scarlet ◆ Cobalt Blue Light ◆ French

Ultramarine Blue ◆ Golden Lake ◆ Indigo ◆

Leaf Green ◆ New Gamboge ◆ Opera ◆

Payne's Gray ◆ Peacock Blue ◆ Permanent Rose

◆ Quinacridone Purple ◆ Royal Blue ◆

Sap Green ◆ Ultramarine Deep ◆ Violet Grey ◆

Winsor Red ◆ Winsor Violet

■ You will see this painting come to life and glow with exciting color right before your eyes and learn how to make your paintings glow, too! It's a process of planning out your painting first, then having fun creating all the beautiful colors to make your painting glow. The first step is to arrange your composition and lighting. Lighting is one of the most important aspects in painting because it creates a variety of values. I like to select something that attracts me and that I would like to paint. I love roses and vases with backlighting, so that is what I chose to show you how to use underpainting and backlighting.

Drawing thumbnail sketches will give you an idea of how to compose your painting. Doodle as much as you can. I have 72 rose bushes, so I have a fresh vase of roses on my kitchen table every day. I love the way the sun hits them in the morning. I started to think, "How would I compose a painting of these beautiful roses?"

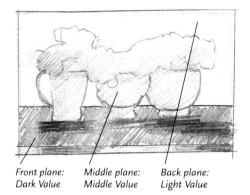

Front plane: *Middle plane:* *Back plane:*
Dark Value *Middle Value* *Light Value*

1 The Composition

Carefully select three vases. Compositions using odd numbers are more interesting to the viewer. Be aware of the negative shapes behind the vases and roses. Carefully consider the shapes and sizes of the vases and the colors of the roses and how they interact. The darker rose on the right balances out the heaviness of the left vase. Start with something you like and then doodle it into a pleasing composition. Try to set it up the way you doodled it in your sketchbook. This method starts you thinking and allows you to create your own composition. Carefully consider the planes of the painting and where to place them for the best lighting. These sketches show some of the considerations for the different planes to make the subject stand out.

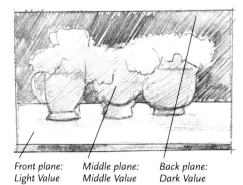

Front plane: *Middle plane:* *Back plane:*
Light Value *Middle Value* *Dark Value*

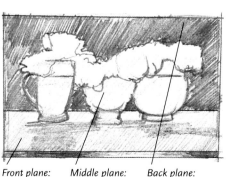

Front plane: *Middle plane:* *Back plane:*
Middle Value *Light Value* *Dark Value*

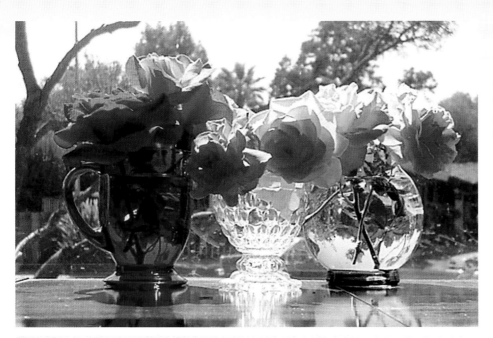

Take a Reference Photo

2 Once the setup is composed you should photograph it. It is always best to paint from life, but unfortunately these roses wanted to open up very quickly in this light. Be sure your composition emphasizes the colors and values the backlighting creates.

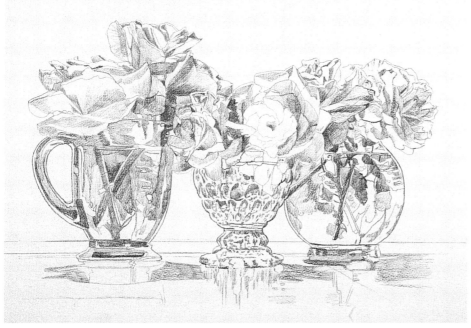

Draw Your Composition

3 Carefully draw the composition directly onto your watercolor paper using three distinct values. Draw the dark and middle values using a no. 2 pencil. Use the white of the paper for your lightest value and stick with it throughout the whole painting.

After you have drawn your subject, it is now time to lightly erase it! Take a kneaded eraser and gently erase the drawing enough to remove the excess graphite but still have a map of your values. This way you can have more time to think and create colors instead of referring to your photograph.

4. Underpaint the Red Roses and the Blue Vase

Look through the blue glass of the vase and exaggerate the colors for your underpainting. Try to identify the colors with ones on your palette. First discern the temperature, then pick out the highest intensity of it in your palette. In the blue vase, there is a pink-purple-blue color. Paint these cool tones in a number 6 or 7 value using Alizarin Crimson, Blue Violet and Permanent Rose. The value needs to be dark enough so that the underpainting shows through the overpainting.

To underpaint the vase use Peacock Blue, Permanent Rose, Winsor Violet, Blue Violet, Sap Green, Cadmium Red Orange, Opera and Alizarin Crimson. Follow the values in the drawing, but try not to place all of them in yet.

Underpaint the rose using Quinacridone Purple, Permanent Rose, Alizarin Crimson, Cadmium Red Orange, Brilliant Pink, Opera, Winsor Red and New Gamboge. Watch your value drawing closely as you place your colors. Allow the painting to dry completely.

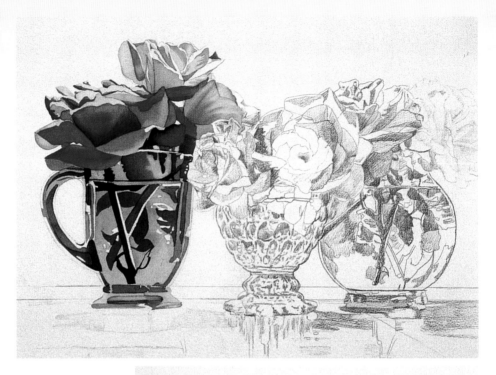

5. Overpaint the Red Roses and Blue Vase

After the underpainting is completely dry, mix a warm blue and a cool blue. Use Royal Blue with a touch of French Ultramarine Blue for the cool blue and Peacock Blue for the warm blue. Glaze over the entire underpainting and around some of the light shapes. Let that dry and add the darker shapes with Sap Green and Indigo. Lift the lights out with a flat bristle brush and straighten the edges.

Repeat the same process, lift, paint around and add details. The warm pinks for the roses are Permanent Rose mixed with Cadmium Orange. The cool pinks are Alizarin Crimson and Permanent Rose.

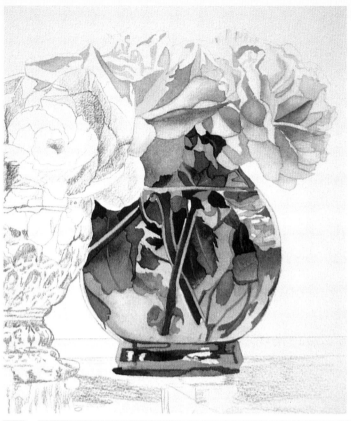

6 Paint the Pink Roses

The colors for the right end roses are Cadmium Red Orange, Permanent Rose, Brilliant Pink and Violet Grey.

Underpaint the right end vase using Sap Green, Cobalt Blue Light, Golden Lake, Ultramarine Deep, Winsor Violet, Burnt Sienna, Alizarin Crimson and Leaf Green.

Let this application dry. Sticking to your value drawing, glaze a warm and a cool overpainting and then add the detail and some darks using Indigo. At the end, lift out some color to place the highlights and put in detail.

7 Paint the Yellow Roses

Paint the underpainting for the middle roses using Permanent Rose, Cadmium Scarlet, Quinacridone Purple, Bright Violet, New Gamboge, Winsor Violet and Brilliant Pink.

Paint the Background

8 You want a rich, cool blue-green complementary background to show off the roses and backlighting effect. Paint directly on the paper going from color to color. When the paint has dried a little, take the round bristle brush and lift out round shapes. You want the background to look soft and out of focus so the roses have sharp edges and look in focus. Also watch the values in the background. You don't want a flat value. Try to put dark next to light and light next to dark. The background colors are Indigo, Sap Green, Ultramarine Deep, Payne's Gray and Alizarin Crimson.

Use an underpainting of Permanent Rose, Alizarin Crimson and some Peacock Blue for the shadows in the foreground.

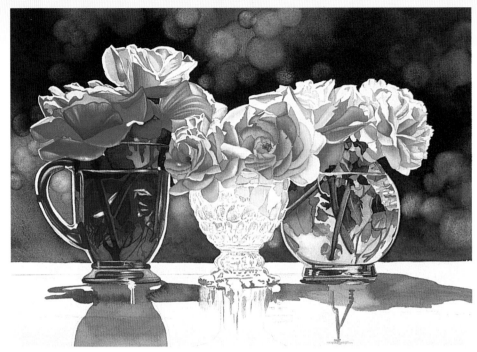

Overpaint the Foreground

9 After the background is done, you will know which values to use for the foreground. Start with the shadows from the vases, a little darker at the base and into the light. Overpaint it with Royal Blue and French Ultramarine Blue. Notice how the underpainting glows through.

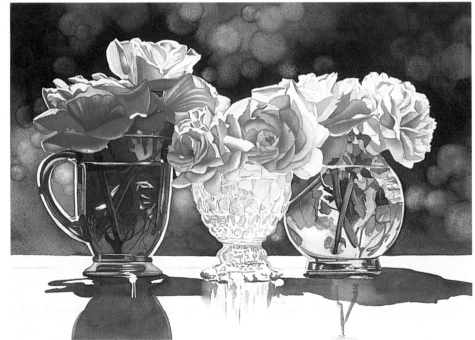

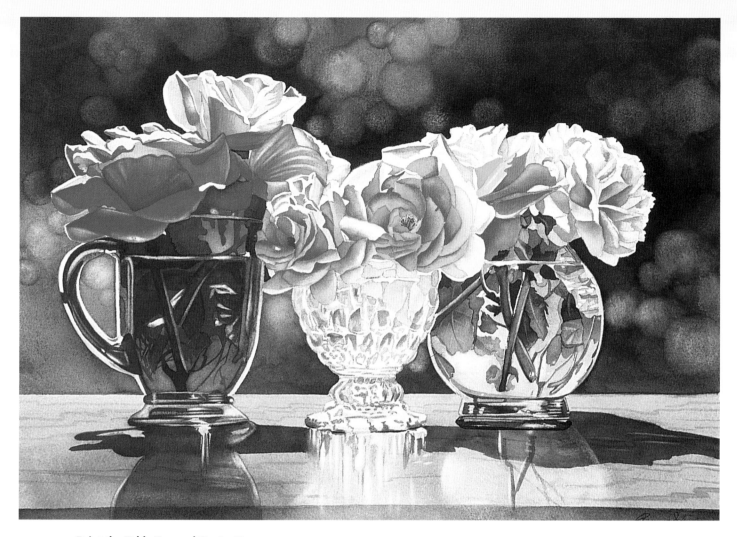

10 Paint the Table Top and Center Vase

When dry, mix a nice, rich warm brown for the front area and a cooler, neutral lighter brown for the back to create depth. Glaze over the whole bottom and lift out where the clear vase reflects with a flat bristle brush. Don't let the shadows drop out of the picture plane; stop them with a ledge on the bottom, gradate and pick up some of the colors of the roses and background into the foreground.

Paint the center vase last. Use colors from the background but much lighter in value and soften some of the edges. Paint darks under each vase to anchor them to the table. Set the painting aside and study it for a while. Then adjust the color, value and temperature where needed. Notice the beautiful effect of the soft and hard edges together and the nice balance of color temperature. The underpainting makes it glow!

Tres Vases Con Rosas · *Watercolor on Arches 300-lb. (640gsm) cold-press paper 15" x 22" (38cm x 56cm)*

Underpainting and Overpainting the Portrait

UNDERPAINTING

If you look at people's skin tones you'll see lots of different colors. Try to exaggerate them on your underpainting and then overpaint as little or as much as you like. This is the pure beauty of watercolor, when the underpainting peeks through and the colors just glows—that's the magic of layering! Paint the color you see by glazing different layers. It's a great lesson and will help you learn both the wash technique and your color personalities.

❧

Palette

Alizarin Crimson ◆ Bright Rose ◆ Bright Violet

◆ Burnt Sienna ◆ Cadmium Red Orange ◆

Cadmium Scarlet ◆ French Ultramarine Blue ◆

Golden Lake ◆ Green Blue ◆ Indigo ◆

New Gamboge ◆ Oxide of Chromium ◆

Payne's Gray ◆ Perylene Maroon ◆

Permanent Rose ◆ Quinacridone Purple ◆

Royal Blue ◆ Sap Green ◆ Sepia ◆

Warm Sepia ◆ Winsor Blue ◆ Winsor Red ◆

Winsor Violet ◆ Yellow Ochre

■ I photographed *Miss Renee Lynn* using indoor lighting, as opposed to outdoor lighting. I wanted the lighting to be soft and subtle and still be able to show off the colors. I then made my color notes and a few sketches. I photographed her in several poses, with and without the hat. I like this photograph because of the way the soft lighting strikes her face. She's a wonderful model and I am proud to say she's my daughter. Ever since she was a little girl, she has been sitting for me to paint from life or posing for my camera with different costumes and headdresses.

After I decided on the pose, composition and completed my thumbnails, I then began drawing on my Arches bright white 300-lb. (640gsm) cold-press watercolor paper in the three values. While drawing, I thought a lot about making the final work of art a drawing, not a painting. My favorite thing to do is draw and I was very compelled to just draw this image. I got a little carried away with the drawing and actually put in more than three values. It's so great to get caught up in your work. Just let it flow—you never know where it will lead you!

Reference Photograph

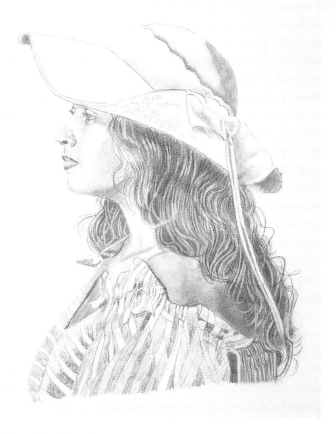

1 Draw the Portrait
Draw the image on Arches bright white 300-lb. (640gsm) cold-press watercolor paper. Make sure you include all three values.

2 Erase the Drawing
Use a kneaded eraser to erase the entire drawing, leaving just a ghost image. This is your map so you know where your values are, allowing you to concentrate on color.

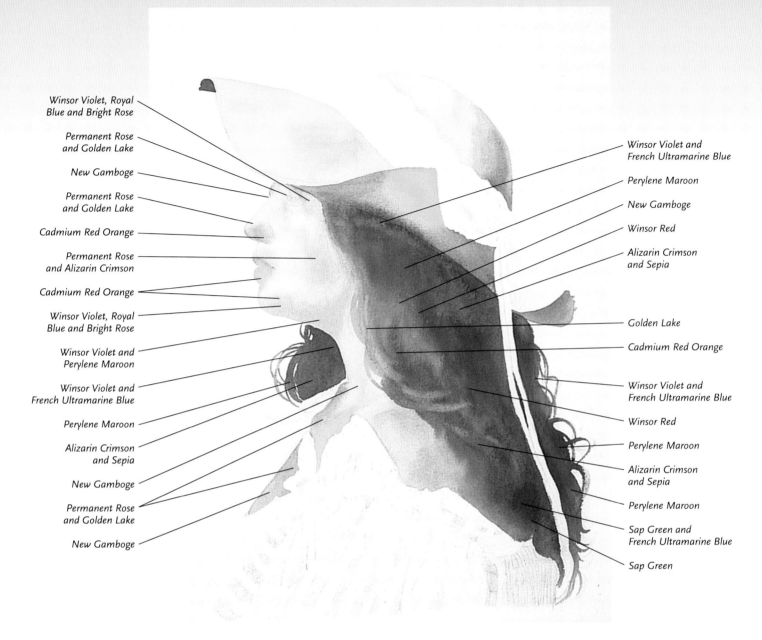

Winsor Violet, Royal
Blue and Bright Rose

Permanent Rose
and Golden Lake

New Gamboge

Permanent Rose
and Golden Lake

Cadmium Red Orange

Permanent Rose
and Alizarin Crimson

Cadmium Red Orange

Winsor Violet, Royal
Blue and Bright Rose

Winsor Violet and
Perylene Maroon

Winsor Violet and
French Ultramarine Blue

Perylene Maroon

Alizarin Crimson
and Sepia

New Gamboge

Permanent Rose
and Golden Lake

New Gamboge

Winsor Violet and
French Ultramarine Blue

Perylene Maroon

New Gamboge

Winsor Red

Alizarin Crimson
and Sepia

Golden Lake

Cadmium Red Orange

Winsor Violet and
French Ultramarine Blue

Winsor Red

Perylene Maroon

Alizarin Crimson
and Sepia

Perylene Maroon

Sap Green and
French Ultramarine Blue

Sap Green

Complete the Underpainting

3 Decide what kind of color temperature you want. Take a piece
of scrap paper and lay down some colors to get a feel of how they
would look. It's much better to work things out before making mistakes
on the painting, especially when working with a portrait. This process
should take 10 or 15 minutes. Take each element separately. You don't
want an all flesh-looking color. There are many different colors in skin;
look for them and relate what you see to the colors on your palette.

Begin with the face. The front of the face is about 25 percent warm
colors and 75 percent cool colors, mostly on the side of the face.

The warm underpainting colors on the face are New Gamboge, Cad-
mium Red Orange and Permanent Rose mixed with Golden Lake and
Sap Green. The cool underpainting colors are Winsor Violet mixed with

Royal Blue (to cool it) and Bright Rose. Use Permanent Rose, Winsor
Violet and Perylene Maroon for the shadow color under the chin. Use
Permanent Rose mixed with Alizarin Crimson under the cheekbone.

The warm underpainting hair colors are (from front to back) Golden
Lake, Cadmium Red Orange, New Gamboge, Perylene Maroon, Winsor
Red and Sap Green. The cool underpainting hair colors are Winsor Vio-
let mixed with French Ultramarine Blue, Alizarin Crimson mixed with
Sepia, and Sap Green mixed with French Ultramarine Blue. Mix very
strong colors at numbers 6 or 7 in value because darker browns need
to be glazed over these colors. When the darker browns dry, the under-
colors should glow through.

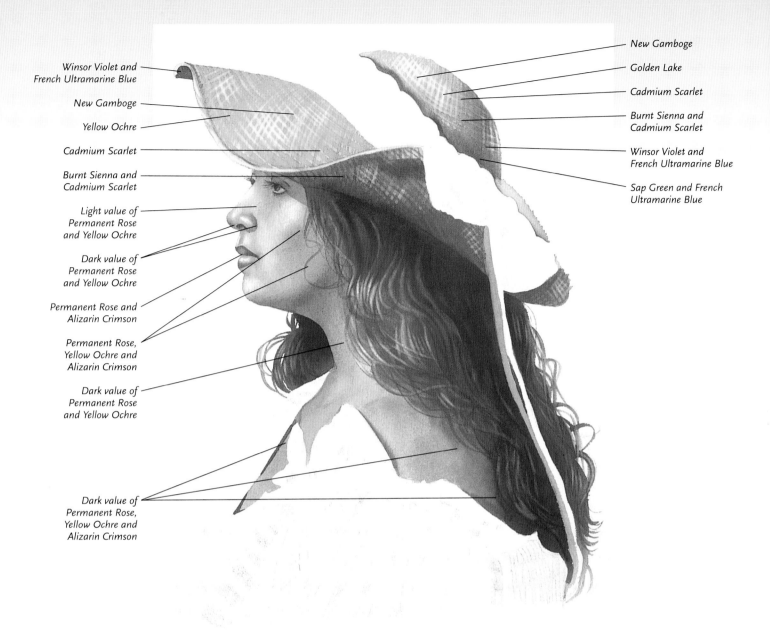

Winsor Violet and
French Ultramarine Blue

New Gamboge

Yellow Ochre

Cadmium Scarlet

Burnt Sienna and
Cadmium Scarlet

Light value of
Permanent Rose
and Yellow Ochre

Dark value of
Permanent Rose
and Yellow Ochre

Permanent Rose and
Alizarin Crimson

Permanent Rose,
Yellow Ochre and
Alizarin Crimson

Dark value of
Permanent Rose
and Yellow Ochre

Dark value of
Permanent Rose,
Yellow Ochre and
Alizarin Crimson

New Gamboge

Golden Lake

Cadmium Scarlet

Burnt Sienna and
Cadmium Scarlet

Winsor Violet and
French Ultramarine Blue

Sap Green and French
Ultramarine Blue

4 The Hat and Flesh Colors

The underpainting on the hat is warm to cool, the hat being mostly warm. Consider about 75 percent warm for the front of the hat, and only 25 percent cool for the back and some underneath. The warm underpainting hat colors are New Gamboge, Golden Lake, Yellow Ochre, Cadmium Scarlet and Burnt Sienna mixed with Cadmium Scarlet. The cool underpainting hat colors are Winsor Violet mixed with French Ultramarine Blue and Sap Green mixed with French Ultramarine Blue.

Now that you've had fun with the underpainting, it's time to calm down a little and mix up the flesh colors. Make sure the warms are a little lighter in value than the cools. You can see the gradation. This is an example of blending color-to-color directly on the paper. See how it comes in handy.

Mix a warm flesh color and a cool flesh color. The warm overpainting flesh colors are Permanent Rose mixed with Yellow Ochre. Use different values of this. For instance, use a darker value under the nose to help form it and a lighter mixture of the same color on top of the nose because it is in direct light. Concentrate on varying the values of the same color. It is helpful to print your photograph in black and white and pay close attention to your value drawing. Think about the form and light. The cooler flesh colors are Permanent Rose, Yellow Ochre (a very small amount) and Alizarin Crimson.

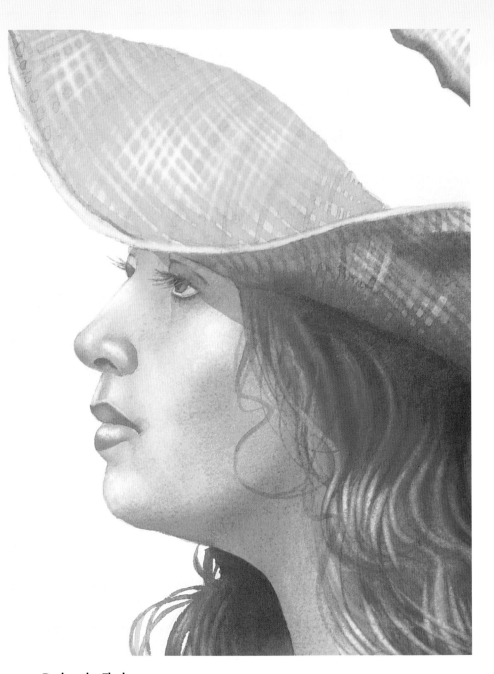

BEAUTIFUL FLESH TONES

The color on the left is a combination of
Permanent Rose and Yellow Ochre.
Use this combination when you need
a warm skin tone. The color on the right
can be used when you need cool skin
tones. It is a mix of Permanent Rose,
Yellow Ochre and Alizarin Crimson.

⁊

5 Darken the Flesh
In places where the skin tones need to be darker, add Winsor Vio-
let to the flesh colors. Again, concentrate on form. Find out where
things are in shadow and where things turn around.

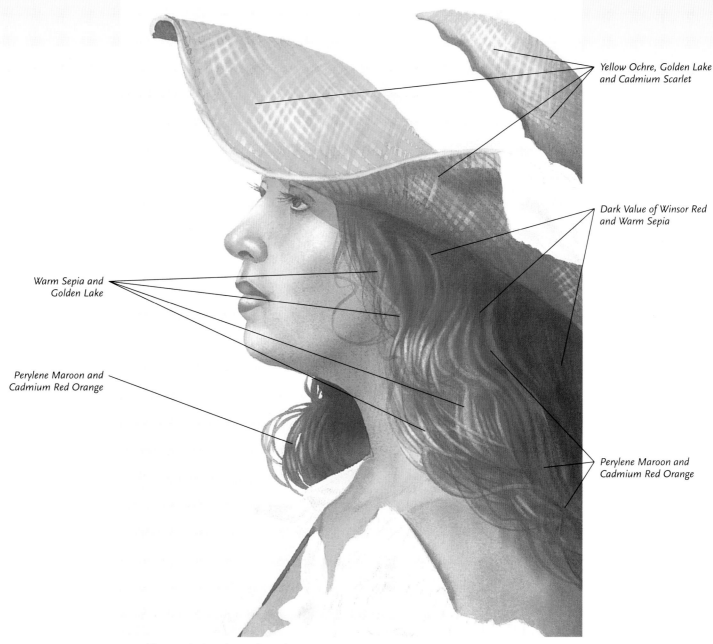

Yellow Ochre, Golden Lake
and Cadmium Scarlet

Dark Value of Winsor Red
and Warm Sepia

Warm Sepia and
Golden Lake

Perylene Maroon and
Cadmium Red Orange

Perylene Maroon and
Cadmium Red Orange

6 Overpainting the Hair and Hat

The warm overpainting hair colors are Golden Lake, Warm Sepia, Perylene Maroon and Cadmium Red Orange. You can also use Winsor Red mixed with Warm Sepia, as it produces a nice, rich warm brown. The cool underpainting hair colors are Sepia mixed with French Ultramarine Blue and/or Winsor Violet and French Ultramarine Blue.

The warm overpainting colors on the hat are Yellow Ochre and Golden Lake mixed with a tad of Cadmium Scarlet. The cool overpainting colors on the hat are Winsor Violet and Sap Green mixed with French Ultramarine Blue.

Don't worry too much about the cooler colors because you are utilizing the complementary colors. The blue on top of the orange and the Sap Green on top of the Burnt Sienna neutralize or cancel each other out, so it is pushed a little over to the cool side and works great in this area!

THE AIRBRUSH

The airbrush is one of my most important tools in painting. It's a pen-like brush that emits air (with the use of a compressor or canned air) and paint at the same time. You can control both the amount of paint you are applying and the value. You can paint opaquely or transparently, using watercolor paint, acrylics or inks.

The airbrush can greatly enhance your work. For example, if you have a very watery area created from watermarks or salt but don't want to loose the texture, you can push it back or make it come forward using the airbrush. You can warm it up, cool it down or darken it. You can obtain smooth, clean gradated glazes with no brush lines in seconds.

The dress in this painting was a challenge. It was transparent material with a "see-through" look. In order to obtain that look, I needed the airbrush. If I had used the paintbrush, I would have taken the chance of muddying up the fleshtones with the overglaze. I simply painted the fleshtones first, then the shadows and then the little flower pattern on the dress. When this was completely dry, I used white acrylic ink in the airbrush and lightly glazed over the entire dress, making it look transparent and toning it down so the focal point was her face.

I used Frisket—a low-tac contact paper—to cover the areas where I didn't want the paint to go. I placed the whole sheet of Frisket over the painting and carefully cut out the parts I wanted to airbrush using a craft knife. I kept everything else covered up.

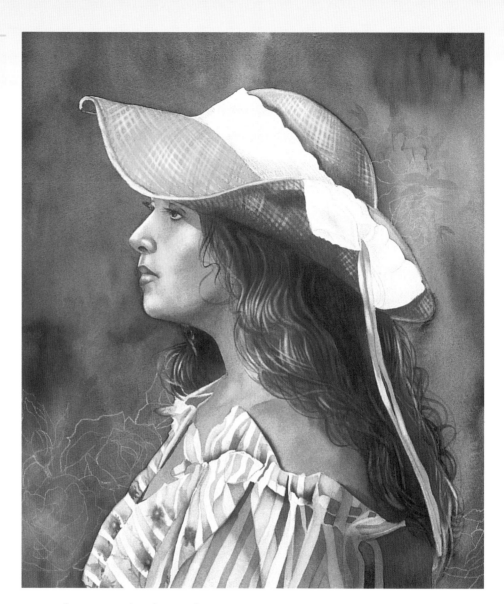

7 The Dress and Background

Paint the dress a little differently. Use a purple mixed with Payne's Gray to paint the stripes. Paint the fleshtones on her arm, under the dress. You want to downplay the dress so the viewer focuses on her face. Use an airbrush with white acrylic ink on top of the dress to downplay it even more and to give the illusion of a transparent material.

Now for the background! You want something to go well with the coolness of the skin tones and complement the portrait. Wet the paper and blast in French Ultramarine Blue, Winsor Blue, Winsor Red and New Gamboge for the darks. Put full-intensity color directly onto the wet surface so that it bleeds together

Add some Green Blue over the background to perk it up. Place some Winsor Violet, Quinacridone Purple, Bright Violet, Indigo and dabs of Golden Lake where you want to place some flowers indiscreetly to complement the portrait.

8 Detail the Background

Apply the colors randomly in the background using the wet-into-wet technique. Allow this to become bone dry. Using a pastel pencil, draw in some loosely formed roses. Paint over the pastel pencil with Bright Rose, Quinacridone Purple and Permanent Rose. The leaf is Sap Green and Oxide of Chromium.

9 Critique

Now is the time to sit back and study the painting to see if there are any changes that need to be made. You can work on a painting so much that you can't see things clearly, so it's back to the basics. Squint your eyes to see what pops out the most. Her face, thank heavens! But also the top of the chair and the white of the hat band, so go back in and tone those down.

When critiquing your work ask these questions: Are your colors fresh and clear? Do you have a variation of temperatures in the piece? Is it an overall cool and soft painting with a relief of warmth in it? Or is it an overall warm painting with some cool accents? How are your values? Is there a good range of values? Are there any flat places without a gradation of value or color? Do things have form?

Notice that her hair is the same value in the back as it is the front, so tone it down in the back using cool colors to create form.

The ribbons from the hat seem a little flat and boring, so give them some more form. They are also way too bright and distract from the face so tone them down as well.

This painting's biggest problem is the strong diagonal created by the flowers that draws your eye out of the picture plane. Go back and resolve this by adding another bud to lift your eye up and take it away from the diagonal. Also, soften the end rose and change its shape.

The nice thing about watercolor opposed to oil painting is the option of cropping the painting once it is finished. By cropping in a little you can focus on her face more. However, you need to have some breathing space in front of the face, so don't crop it too much.

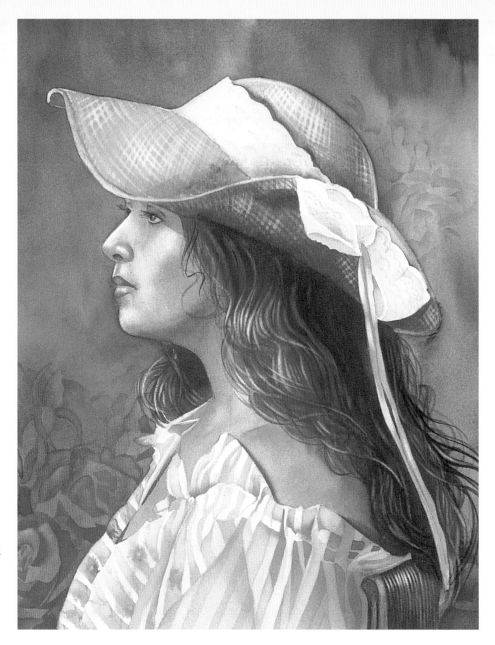

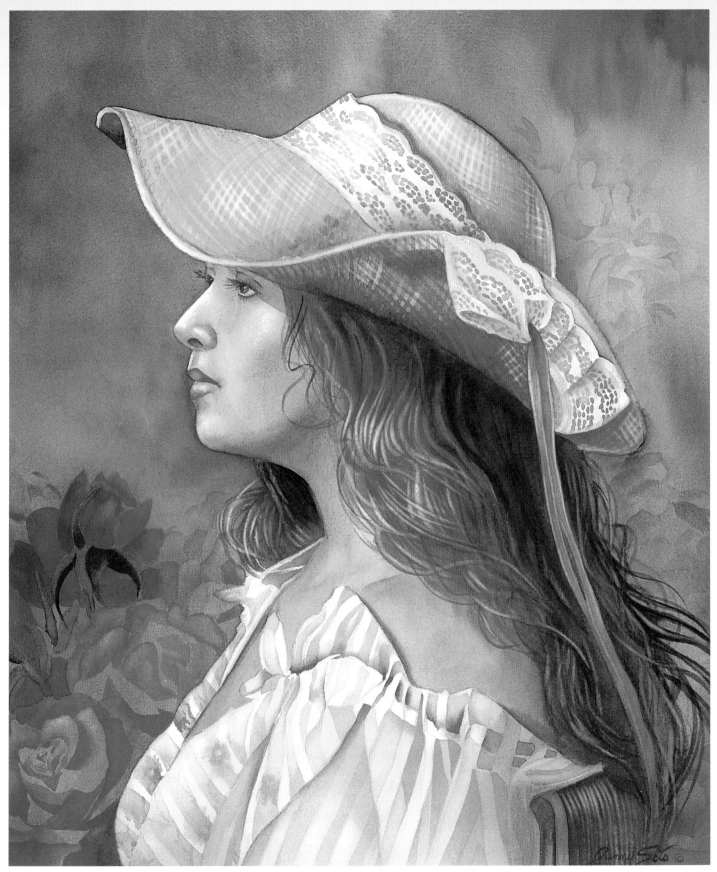

Miss Renee Lynn · *Watercolor on Arches 300-lb. (640gsm) cold-press paper* · *22" x 30" (56cm x 76cm)* · *Collection of Renee Lynn Soto*

Lighting
Effects

Light is the most quintessential part of a painting, other than the inspiration. Take a look back in time at some of the most famous artists—Rembrandt, Degas, Cézanne—and see how they captured light. The way we capture light can make or break a painting. Without light, artwork becomes boring, flat and uninteresting. It is the soul of the statement. Have you ever seen a very nicely rendered piece of artwork that lacked soul and inspiration? It is probably because the values are inaccurate and it basically reads as an all middle-value painting with the lightest and darkest values excluded. Lights and darks make up form and shape. Without lights and darks, the forms become flat, rendering an uninteresting painting.

Well-balanced light holds the eye within the painting and keeps the viewer interested, just like well-balanced color temperatures do. In this chapter we will discuss the different kinds of light, how to create inspirational setups using the right kind of light and how to stick to it without having your painting become all one value. We will learn how to balance and save the light to make a knockout painting that glows with color and light!

Sylvester · *Watercolor on Crescent Illustration Board* · *15" x 22" (38cm x 56cm)*

Ratios of *Light*

One of the first things you should keep in mind is the light source. Try to actually see how it flatters your subject. You might see the most beautiful subject all in shade and want to paint it, but that is the most difficult thing to do and make work.

Let's start by looking at our subject in percentages again. Set up a still life using a spotlight. You want to create a scene with 25 percent light and 75 percent shadow. Note how interesting the shadow and the ratio of light to dark is. Now change the spotlight to create a scene using 75 percent light and only 25 percent shadow. Decide what flatters the subject. Compositions are most flattering when the light is varied. You want a light ratio of about 25 to 75 percent on your subject. A 50 to 50 percent ratio, like the color temperatures, is boring to the eye. These examples of color percentages will help you to understand light, middle and dark values.

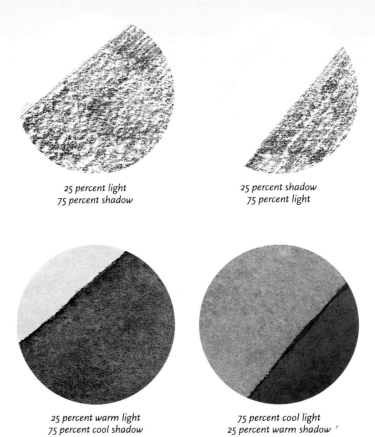

25 percent light
75 percent shadow

25 percent shadow
75 percent light

25 percent warm light
75 percent cool shadow

75 percent cool light
25 percent warm shadow

Examples of Lighting
Start with the subject matter. It doesn't have to be exactly that percentage, this is just to get you started thinking about the ratio between light and dark.

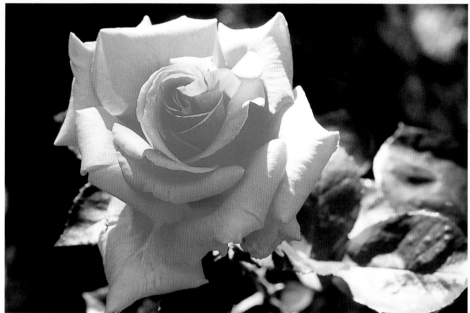

Balance Your Temperature

This photograph is a perfect example of 75 percent cool dark and 25 percent warm light. Notice the yellows in the warm area and the blues in the cool areas. Add 10 percent warm into the cool area and 10 percent cool into the warm area. This perfectly balances out the color temperature.

Squint to See Temperature

If you squint your eyes you will see 75 percent warm light and 25 percent cool dark. Notice the blue-pinks in the cool shadows.

Different *Types of Lighting*

CAPTURING LIGHT

If you take your photos with a 35mm camera, use a photographic bulb for indoor use. I use a General Electric EBW no. B2 115-120 bulb with 100 or 200 ASA print film. You can find this bulb at your local photography store. Turn off all other lighting and use this single source of light. You will see how dramatic this light can be and how it can put emotion in your paintings.

Let's discuss the different ways to light subject matter. You can use direct lighting from above, without any ambient light—that's an easy one. You can use window lighting, outdoor, filtered light or flood lighting, also known as spotlighting. All of these different types of light create different effects.

Window Lighting
Window lighting is a soft subtle light, which is very flattering to subjects. This is 25 percent light and 75 percent dark image. It is best if you can photograph with light from only one window. Other windows could interfere with your window lighting by casting additional light on your subject, making it more difficult to paint.

Mid-Valued, Filtered Lighting
This is a lovely photo of flowers. This image would be very hard to paint unless you are aware of the values and consciously avoid making it an all middle-value painting. This was taken on an overcast day, making the lights and darks very subdued and even. It is not that you can't paint this image, you'll just have to be aware of the values to make it work.

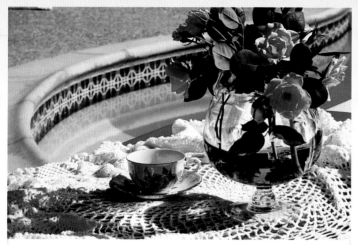

Outdoor Lighting

This is my favorite type of lighting—sunlight. I love the transparent colors of the cast shadows reflecting the color of the subject matter. Try placing things differently and experiment by connecting the shadows and creating beautiful shapes of shadow and light.

Floodlighting

Floodlighting is one of the most dramatic forms of lighting. You can have fun with this light source because of how much control you have. Use an adjustable light stand so you can control the height of the light. Try using the floodlight in different ways. Cast the light from below by focusing the light upward from a very low angle. Or use floodlighting from overhead to cast light across the top of the subject. Try front lighting, side lighting, backlighting and very close lighting. Be creative. Don't use a flash because it will flatten the light.

Sylvester on page 72 is a good example of a painting using flood lighting. I walked into the room and there he was under the lamp. This spotlight effect brought out the beautiful colors in his fur.

Creative Lighting

Use your imagination and be creative with lighting! Outside light is best to begin experimenting with. There are no other interfering light sources around and it will not burn out (until dusk)! And it is the most interesting. If you photograph in this light, sometimes when you get your photos back, the light areas will be washed out. That's why you always record the correct values in your sketchbook. Try to have a darker print of the negative to show you what's in the light.

Take a piece of white mat board outside and set up your still life on it. Squint your eyes and look at the percentages of light and dark. Walk around the setup and take photographs at different angles and positions. Use the entire roll of film. Get your sketchbook and record what you see in front of you. Note the reflected light in the shadows from the subject matter, and exaggerate them in your painting. Note the shapes of the shadows and how they are connected as well as the way the light falls on the subject matter.

❧

Backlighting

Backlighting is another dramatic source of light that is fun to paint. The most important thing to remember when using backlighting is to save the light areas.

Backlighting

Palette

Alizarin Crimson ◆ Aureolin ◆ Bright Violet ◆

Blue Violet ◆ Burnt Sienna ◆ Cadmium Lemon

◆ Cadmium Red Orange ◆ Cadmium Scarlet

◆ French Ultramarine Blue ◆ Garnet Lake ◆

Golden Lake ◆ Indigo ◆ New Gamboge ◆

Payne's Gray ◆ Opera ◆ Permanent Rose

◆ Perylene Maroon ◆ Quinacridone Purple ◆

Rose Lake ◆ Rose Violet ◆ Sap Green ◆

Tyrian Rose ◆ Winsor Violet

■ The backlighting on this rose makes a wonderful subject to exaggerate your colors. It is a great exercise for you to try and save the light areas!

Reference Photograph
I waited until the light was behind the rose to take my photograph. Backlighting can really enhance color. In this photo the rose is 75 percent dark shadow and 25 percent light. It just glows off the paper!

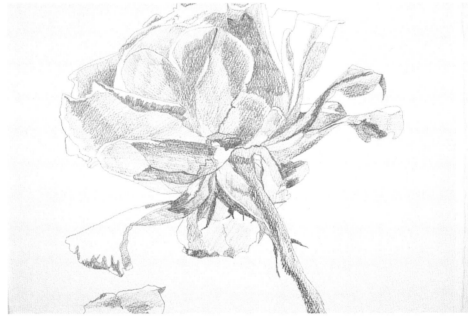

1 The Three-Value Drawing
Draw the image onto your watercolor paper, using 300-lb. (640gsm) Arches cold-press paper. You don't have to stretch the paper. Be sure to capture the three values on the drawing and gently erase them, creating a ghost of the image. Now you are ready for the underpainting—the fun and creative part.

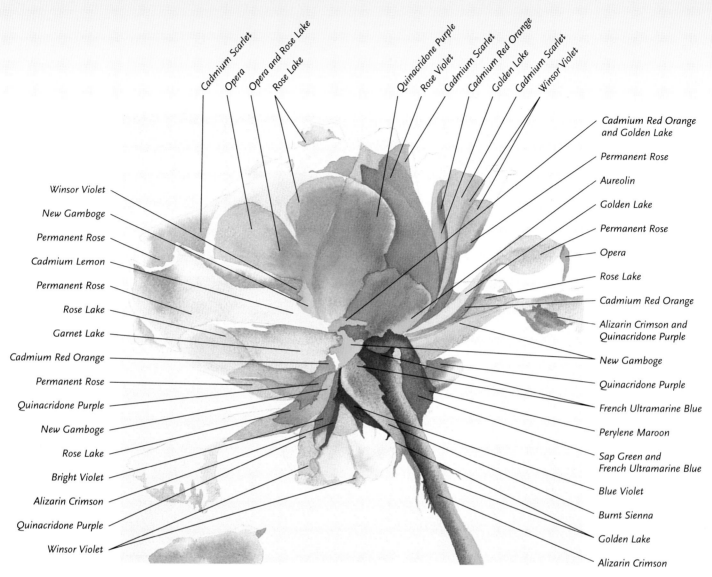

Cadmium Scarlet
Opera
Opera and Rose Lake
Rose Lake

Quinacridone Purple
Rose Violet
Cadmium Scarlet
Cadmium Red Orange
Golden Lake
Cadmium Scarlet
Winsor Violet

Cadmium Red Orange and Golden Lake
Permanent Rose
Aureolin
Golden Lake
Permanent Rose
Opera
Rose Lake
Cadmium Red Orange
Alizarin Crimson and Quinacridone Purple
New Gamboge
Quinacridone Purple
French Ultramarine Blue
Perylene Maroon
Sap Green and French Ultramarine Blue
Blue Violet
Burnt Sienna
Golden Lake
Alizarin Crimson

Winsor Violet
New Gamboge
Permanent Rose
Cadmium Lemon
Permanent Rose
Rose Lake
Garnet Lake
Cadmium Red Orange
Permanent Rose
Quinacridone Purple
New Gamboge
Rose Lake
Bright Violet
Alizarin Crimson
Quinacridone Purple
Winsor Violet

2 Underpaint the Rose

Follow along with these colors to complete the underpainting of the rose. Alter the values of the paint by using water to thin the pigments.

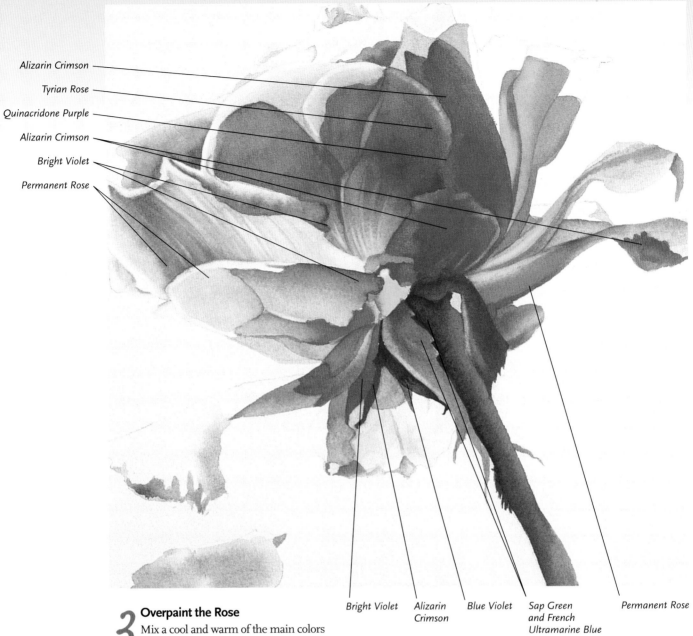

Alizarin Crimson

Tyrian Rose

Quinacridone Purple

Alizarin Crimson

Bright Violet

Permanent Rose

Bright Violet

Alizarin Crimson

Blue Violet

Sap Green and French Ultramarine Blue

Permanent Rose

3 Overpaint the Rose

Mix a cool and warm of the main colors you will be using. Be careful not to glaze over complementary colors or use too much paint. You essentially want the undercolors to glow through, so nice thin glazes work well. Now you can make your darks darker and lighten your lights. In other words, gradate at the bottom and lighten at the top.

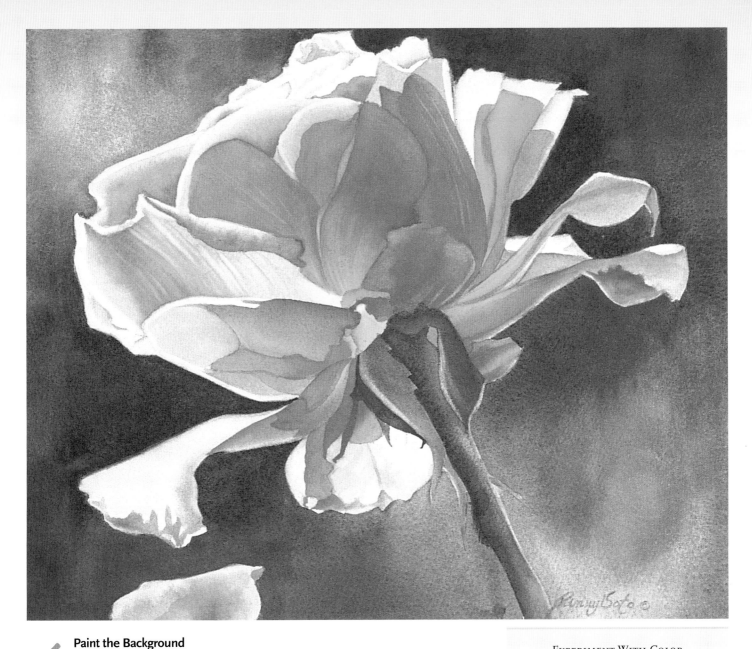

Paint the Background

4 You want the background to complement the focal point. Play light against dark and dark against light. Add some pinkish purples to the background to integrate it with the rose. The richness of the darks really brings out the colors of the rose as well. Use Indigo with Sap Green and Payne's Gray for the darkest darks. For the light areas use Winsor Violet with French Ultramarine Blue and Payne's Gray. Paint directly on the paper, mixing the colors without wetting the paper. You want complete control, so use the color-to-color technique (see page 50). When finished with the background, lift out the very lightest lights on the rose and soften the edges. If you lift out before placing in your background, the dark colors will seep into the lifted-out areas.

Put it up on the easel and study it for awhile, coming back and adjusting things that aren't quite right. Take your flat scrub brush and go all around the painting and soften the edges so that your subject won't look as if it is pasted on!

The Rose · *Watercolor on Arches 300-lb. (640gsm) cold-press paper* · *11" x 15" (28cm x 38cm)*

EXPERIMENT WITH COLOR

Now that you have completed this lesson, do another with a different color rose. Think up your own colors or go and purchase a rose, bring it home and study it. Look through the actual color and try to exaggerate the undercolors. Then glaze the real color in cools and warms on top of your underpainting. Don't forget to draw in the three values first! This will give you a place to go, a map, so you can enjoy and concentrate on colors. I think that's what painting is all about. Go for the glow!

❧

Window Light

Palette

Alizarin Crimson ♦ Brilliant Orange ♦
Burnt Sienna ♦ Cadmium Red Orange ♦
♦ Cadmium Scarlet ♦ Cadmium Yellow Orange ♦
♦ Cobalt Blue Light ♦ French Ultramarine Blue
♦ Golden Lake ♦ Indigo ♦ Leaf Green ♦
New Gamboge ♦ Opera ♦ Payne's Gray ♦
Peacock Blue ♦ Permanent Rose ♦ Perylene
Maroon ♦ Quinacridone Purple ♦ Rose Lake ♦
Royal Blue ♦ Sap Green ♦ Sepia ♦ Warm
Sepia ♦ Winsor Red ♦ Winsor Violet

■ In this demonstration, we will use window lighting. I set up this still life by my kitchen window with wonderful sunlight pouring in. I turned the bowl around until I had it in a good position to create a nice composition. I arranged the persimmons so they were on different planes to make the setup interesting and to create depth. I wanted the lace holes to show the color of the persimmons and integrate some of the orange color in the lace. I then took several different shots of it using my camera. I sat and studied it for awhile, making notes in my sketchbook, especially about the colors that I saw in the persimmons. Even though I knew I was going to paint this from life, I still recorded it with my camera and took notes. You never know when someone in your family will walk by and eat a piece of your subject matter. That's exactly what happened to me!

Reference Photograph

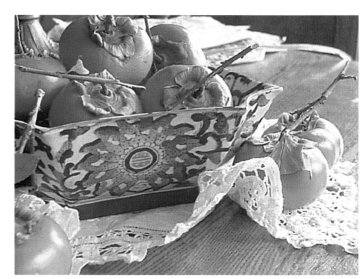

1 The Three-Value Drawing

Use the photograph for a reference and draw a thumbnail in your sketchbook. Your goal is to get a feel for the composition and values. Draw your composition on your watercolor paper. Break down the values into light, middle and dark.

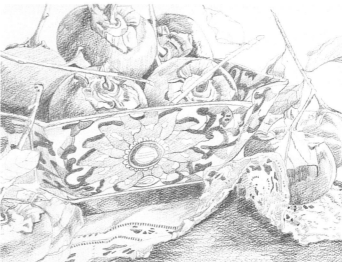

2 Leave a Ghost Image

Gently erase the three-value drawing to leave a ghost image. Now you are ready to begin the underpainting.

3 Establish the Darkest Darks

Start with your darkest dark and block in that color to give you a scale to measure your values. Begin with the base of the bowl, which is painted with Indigo, Permanent Rose and French Ultramarine Blue. Gradate the wash, painting darker on each side to give the bowl roundness. The persimmon in the upper left corner is painted with Alizarin Crimson, Quinacridone Purple and Winsor Violet. Follow the ghost image on your paper, so you are free to concentrate on the colors.

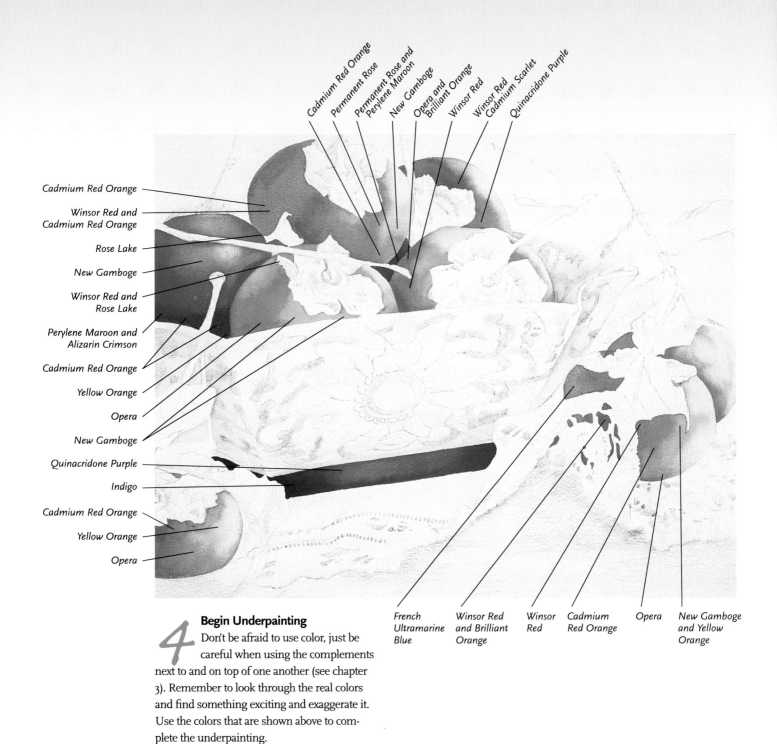

Cadmium Red Orange
Permanent Rose
Permanent Rose and Perylene Maroon
New Gamboge
Opera and Brilliant Orange
Winsor Red
Winsor Red Cadmium Scarlet
Quinacridone Purple

Cadmium Red Orange

Winsor Red and
Cadmium Red Orange

Rose Lake

New Gamboge

Winsor Red and
Rose Lake

Perylene Maroon and
Alizarin Crimson

Cadmium Red Orange

Yellow Orange

Opera

New Gamboge

Quinacridone Purple

Indigo

Cadmium Red Orange

Yellow Orange

Opera

French
Ultramarine
Blue

Winsor Red
and Brilliant
Orange

Winsor
Red

Cadmium
Red Orange

Opera

New Gamboge
and Yellow
Orange

Begin Underpainting

Don't be afraid to use color, just be careful when using the complements next to and on top of one another (see chapter 3). Remember to look through the real colors and find something exciting and exaggerate it. Use the colors that are shown above to complete the underpainting.

5 Overpaint the Persimmons

Overpainting is essentially using the colors you see. So if the persimmons are orangey, you would use cool oranges and warm oranges as the overpainting. Use them sparingly, as you want your underpainting to glow through.

Here are the colors for the overpainting of the persimmons. The warm orange color is Cadmium Scarlet, Winsor Red, Golden Lake and New Gamboge. The cool orange color is Perylene Maroon mixed with Alizarin Crimson, a touch of Quinacridone Purple and Permanent Rose.

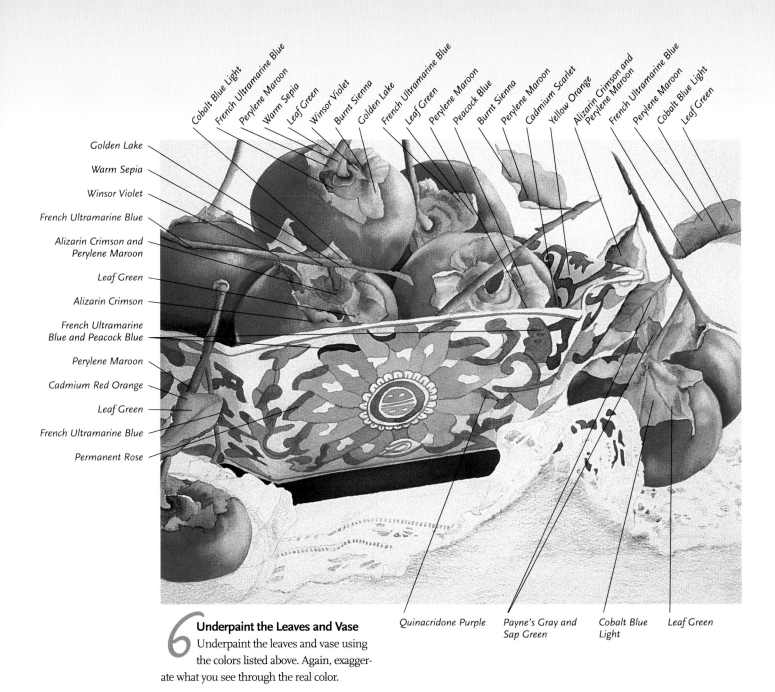

Golden Lake

Warm Sepia

Winsor Violet

French Ultramarine Blue

Alizarin Crimson and
Perylene Maroon

Leaf Green

Alizarin Crimson

French Ultramarine
Blue and Peacock Blue

Perylene Maroon

Cadmium Red Orange

Leaf Green

French Ultramarine Blue

Permanent Rose

Cobalt Blue Light

French Ultramarine Blue

Perylene Maroon

Warm Sepia

Leaf Green

Winsor Violet

Burnt Sienna

Golden Lake

French Ultramarine Blue

Leaf Green

Perylene Maroon

Peacock Blue

Burnt Sienna

Perylene Maroon

Cadmium Scarlet

Yellow Orange

Alizarin Crimson and
Perylene Maroon

French Ultramarine Blue

Perylene Maroon

Cobalt Blue Light

Leaf Green

Quinacridone Purple

Payne's Gray and
Sap Green

Cobalt Blue
Light

Leaf Green

6 Underpaint the Leaves and Vase

Underpaint the leaves and vase using the colors listed above. Again, exaggerate what you see through the real color.

Finish

7 After the underpainting is finished, lift out the light areas with a flat scrub brush. Paint the table using a warm brown in the front plane—Warm Sepia, Cadmium Orange and Perylene Maroon. The shadows are cool; Sepia and French Ultramarine Blue work well. There is a subtle gradation from cool left, to warm in the middle and right. As the table goes back it becomes cooler and lighter, so use Sepia, Payne's Gray and French Ultramarine Blue.

For the lace use shades of Cadmium Orange, Winsor Violet and French Ultramarine Blue all toned down with Payne's Gray.

For the vase, use Royal Blue and French Ultramarine Blue in the dark glazes on the left, and Peacock Blue for the lighter glazes on the right.

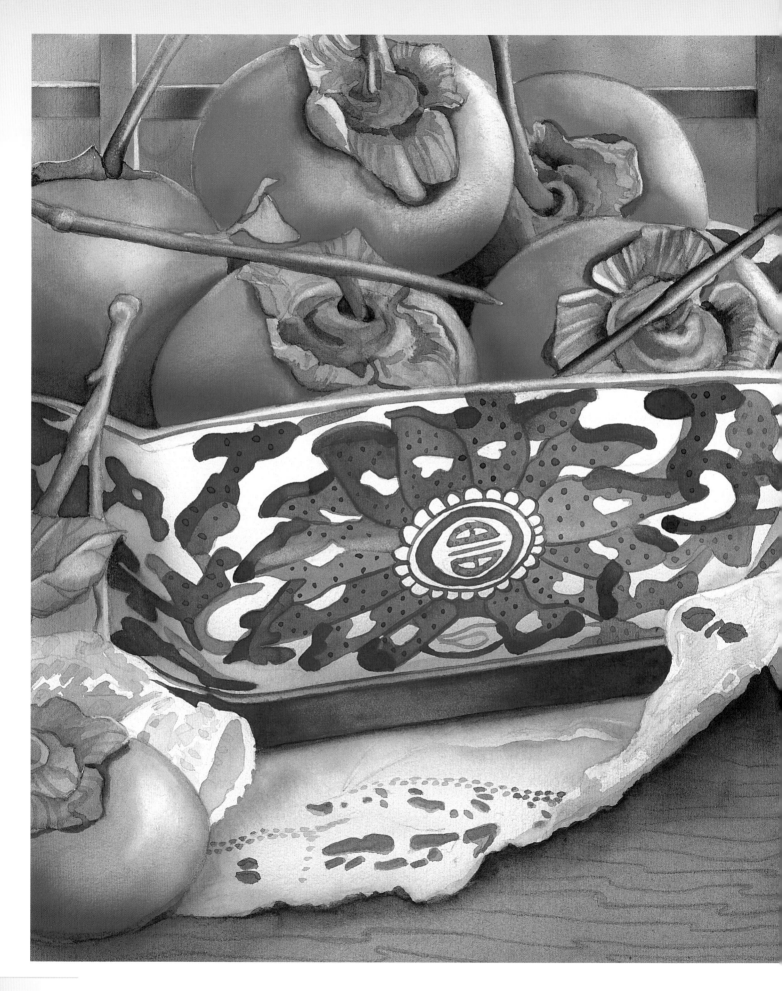

Persimmons · *Watercolor on Fabriano Uno 300-lb. (640gsm) soft-press paper · 12" x 15" (30cm x 38cm)*

Adding Color
To Shadows

Shadows are wonderful and colorful! They anchor objects to the ground, showing off the light, color and dimension, while adding drama to the subject. They also create wonderful shapes and help unify the painting. If you learn to see shadows in color and the colors they capture, you will love painting them! So many artists only see the shadows as gray—they're not.

Benicia Shadows · Watercolor on Arches 300-lb. (640gsm) cold-press paper · 30" x 22" (76cm x 56cm)

Using Subtle Color to *Create Shadows*

SEEING VALUE AND COLOR

If you have a hard time seeing color, try holding up a red piece of mylar to the side of someone's face in strong light. See how the red hue changes the values of the face. You can see them clearly. Go out on a sunny day with a white mat board and place colorful objects on it; study the shadows, and you will be amazed by what you see! Try to associate the colors you see with the colors in your palette, then get a little daring and make them more intense!

❧

Shadows can create another dimension to your work, adding more vibrant color and character. They connect shapes and make your composition more unified. Shadows should enhance your subject matter while directing the viewer's eye gently around the painting.

It's amazing where you find ideas for paintings. I was walking along the street on a hot summer day when I came across this bicycle. I was attracted to the orange and blue complementary colors and then noticed the shadows. I came closer for a better look. My imagination started to take over! I began to see all sorts of colors in the shadows and that suddenly became my focal point. I started to take photographs of it from all kinds of angles. I was nearly lying on the ground at one point. The things artists do!

I love the abstract quality this has as a piece of art, and the luminous colors I could create. I got out my pencil and piece of paper and jotted down some notes on color and design. I couldn't wait to develop the film. The next morning I started the drawing! This particular painting was like a puzzle. The three main parts of it were the bicycle tire, the stand and the shadows. The negative shapes on the ground were all different shapes and sizes, the colors integrated well, and were naturally complementary!

The Hard-Working Shadow

Shadows have tons of responsibilities: they anchor objects, illuminate the subject, connect passages and integrate colors. Most importantly, they add form to the objects in your paintings. In this chapter we will explore all of these ideas, so get ready—our shadows will be following us around!

Bicycle Shadows · *Watercolor on Arches 300-lb. (640gsm) cold-press paper 22" x 30" (56cm x 76cm)*

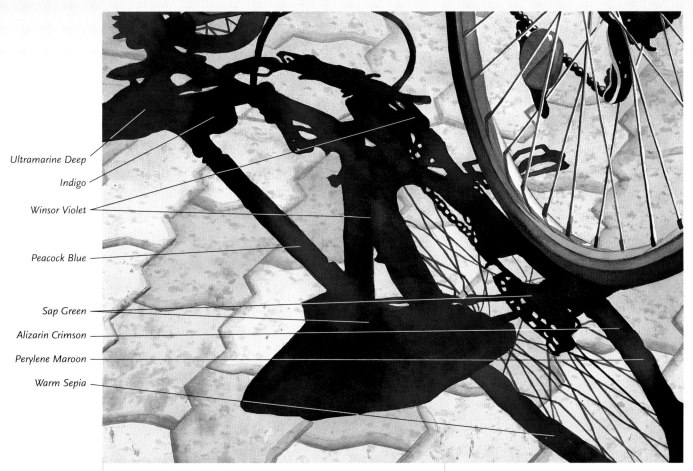

Ultramarine Deep

Indigo

Winsor Violet

Peacock Blue

Sap Green

Alizarin Crimson

Perylene Maroon

Warm Sepia

Create Beautiful Shadows

Focus on creating gradual changes of wonderful colors. It's nice to have the option of leaving your painting just as you see it in real life or exaggerating the color. Don't be afraid to put colors in your shadows; they are there, you just have to find them. There is color all around us, just look and exaggerate it. I have listed the colors I used to make the shadows in my painting *Bicycle Shadows*.

San Juan Baptista Shadows

Palette

Alizarin Crimson ♦ Cadmium Orange ♦
Cadmium Red Orange ♦ Cadmium Scarlet
♦ Golden Lake ♦ Green Blue ♦ Indigo ♦
Leaf Green ♦ Green Blue (Maimeriblu) ♦
Payne's Gray ♦ Perylene Maroon ♦ Primary
Blue ♦ Quinacridone Burnt Scarlet ♦
Quinacridone Burnt Sienna ♦ Sap Green ♦
Sepia ♦ Ultramarine Deep ♦ Warm Sepia ♦
Winsor Violet ♦ Yellow Ochre ♦ Yellow Orange

■ This demonstration uses large washes that need to flow quickly and evenly. I usually paint around areas, but for paintings like these it is easier to apply masking fluid. The foreground is the lightest, the middle ground is the darkest and the background is the middle value. The top is a middle-light value. If you break this down into abstract shapes, all the planes are different sizes, shapes and heights. I think a combination of organic shapes and geometric shapes are a challenge to paint. I also think it adds a lot of character and interest to the piece.

Reference Photograph

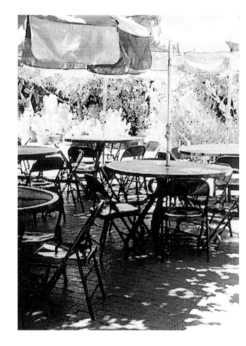

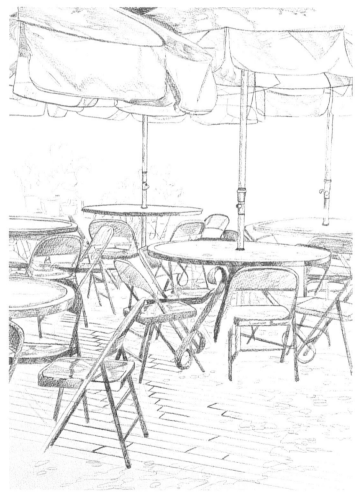

1 The Three-Value Drawing

Begin with a three-value drawing, paying particular attention to the geometric shapes. Divide the planes in the painting and figure out where the values for the planes go. Complete your drawing and erase it to leave a ghost image.

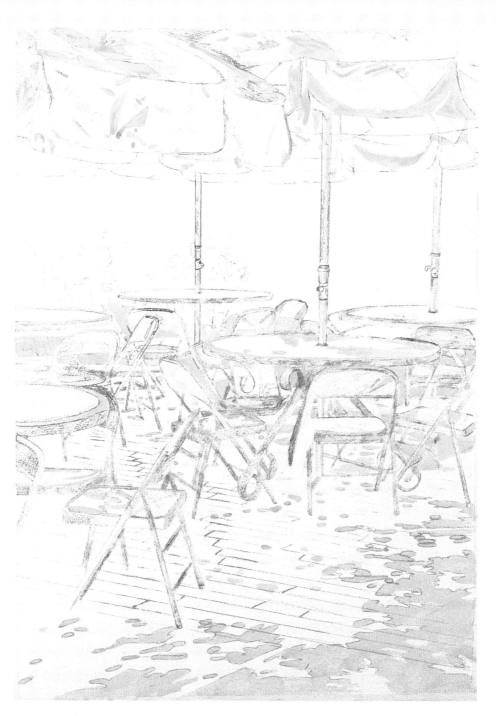

2 Apply the Masking Fluid

You want to protect all the places the sun hits. Mask out all the light areas and the lights of the shadows you want to save using masking fluid and an old brush. Masking fluid comes in a jar and is used to save the white of the paper. Allow the masking fluid to dry for about twenty minutes.

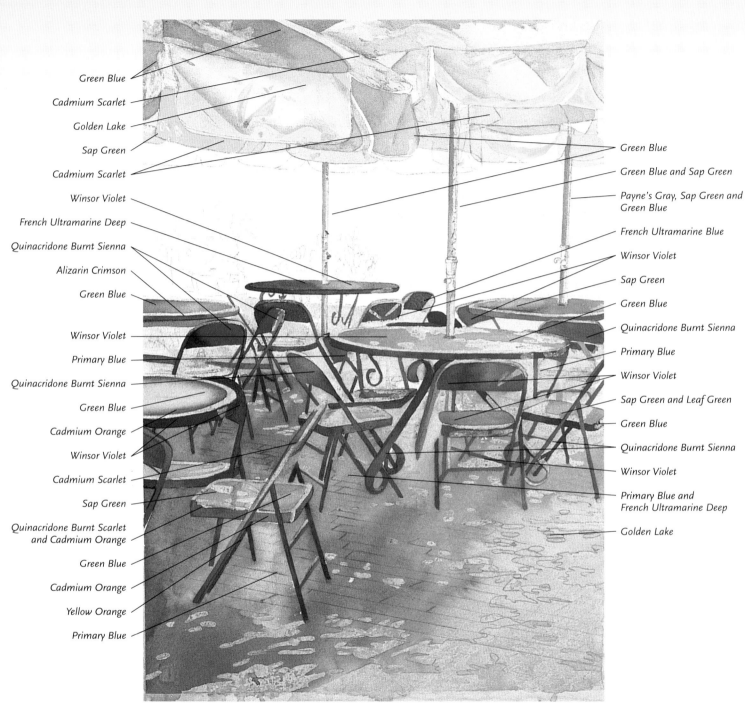

Green Blue

Cadmium Scarlet

Golden Lake

Sap Green

Cadmium Scarlet

Winsor Violet

French Ultramarine Deep

Quinacridone Burnt Sienna

Alizarin Crimson

Green Blue

Winsor Violet

Primary Blue

Quinacridone Burnt Sienna

Green Blue

Cadmium Orange

Winsor Violet

Cadmium Scarlet

Sap Green

Quinacridone Burnt Scarlet
and Cadmium Orange

Green Blue

Cadmium Orange

Yellow Orange

Primary Blue

Green Blue

Green Blue and Sap Green

Payne's Gray, Sap Green and
Green Blue

French Ultramarine Blue

Winsor Violet

Sap Green

Green Blue

Quinacridone Burnt Sienna

Primary Blue

Winsor Violet

Sap Green and Leaf Green

Green Blue

Quinacridone Burnt Sienna

Winsor Violet

Primary Blue and
French Ultramarine Deep

Golden Lake

Paint the Underpainting

3 Lay in your underpainting using the colors indicated on the
image. This is the time to be creative—let your imagination go!

Add the Dark Background

4 Add the dark background so you can place the values correctly by comparing it to the rest of the painting. Use combinations of Sap Green and Indigo, Sap Green and Primary Blue, and Sap Green and Leaf Green.

Create the texture of the leaves by adding a little salt. Apply the wash and before it dries, sprinkle a bit of salt on the wash and then let it dry. Brush the salt from the painting. Paint around the cactus and the pots in the back.

5 Remove the Masking Fluid

When the background is completely dry and the salt has been brushed away, gently remove the masking fluid from the light areas using rubber cement pick-up.

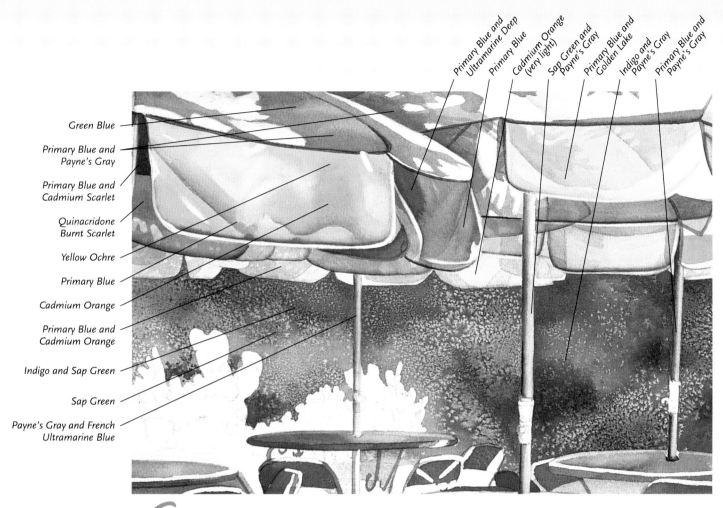

Green Blue

Primary Blue and
Payne's Gray

Primary Blue and
Cadmium Scarlet

Quinacridone
Burnt Scarlet

Yellow Ochre

Primary Blue

Cadmium Orange

Primary Blue and
Cadmium Orange

Indigo and Sap Green

Sap Green

Payne's Gray and French
Ultramarine Blue

Primary Blue and
Ultramarine Deep

Primary Blue

Cadmium Orange
(very light)

Sap Green and
Payne's Gray

Primary Blue and
Golden Lake

Indigo and
Payne's Gray

Primary Blue and
Payne's Gray

6 Overpaint the Umbrellas and Poles

Paint a little more detail and begin to add the overpainting using the correct values. The edges will look extremely hard, but you should only be concerned with the values and depth at this point. You can go back in and soften the edges with the flat scrub brush. Remember, warm colors come forward and cool colors recede.

Use different combinations of Payne's Gray, Sap Green and Ultramarine Deep on the umbrella poles in varying values and temperatures. The warmest pole is in the front, while the two back poles are cooler in temperature.

Now paint the umbrellas. Lift out the light areas and glazed shadow patterns on top of the glazing. Soften some of the edges of the shadows on the umbrellas. Finish the umbrellas to get the feel for the whole painting.

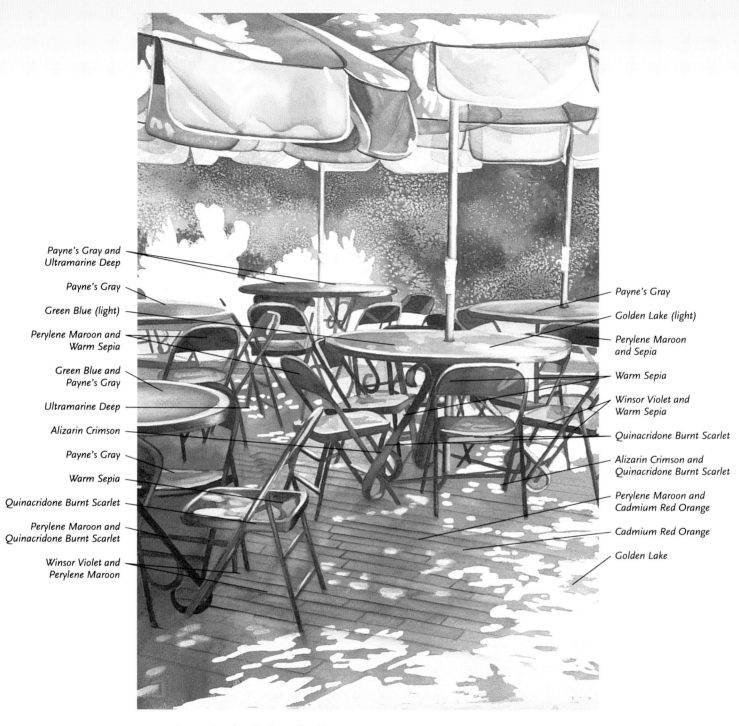

Payne's Gray and
Ultramarine Deep

Payne's Gray

Green Blue (light)

Perylene Maroon and
Warm Sepia

Green Blue and
Payne's Gray

Ultramarine Deep

Alizarin Crimson

Payne's Gray

Warm Sepia

Quinacridone Burnt Scarlet

Perylene Maroon and
Quinacridone Burnt Scarlet

Winsor Violet and
Perylene Maroon

Payne's Gray

Golden Lake (light)

Perylene Maroon
and Sepia

Warm Sepia

Winsor Violet and
Warm Sepia

Quinacridone Burnt Scarlet

Alizarin Crimson and
Quinacridone Burnt Scarlet

Perylene Maroon and
Cadmium Red Orange

Cadmium Red Orange

Golden Lake

Overpaint the Chairs and Tables

Begin with the overpainting on the chairs. When painting the chairs and tables, try to vary your color combinations using different hues and temperatures so you capture their form.

Use a soft watercolor brush for the overpainting, being careful not to disturb the underpainting. Be very careful with the complementary colors; don't get too carried away with the contrast. When the overpainting is strong and intense enough, take your flat scrub brush and lift out some of the paint in the light areas to soften the image.

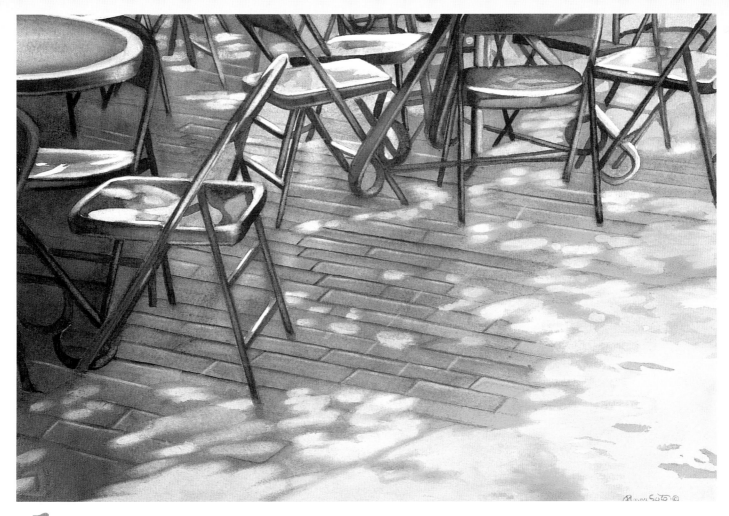

8 Redraw the Tile

Pencil in the lines of the tile, making sure you get the perspective right; don't just rely on your photograph. Use Warm Sepia on the front lines, softening one edge. Use Sepia in the background, again softening the edges. When this dries, take your flat scrub brush and lift the paint where the light hits the tile to give it a little thickness. Clean up the edges on the chairs with the flat scrub brush.

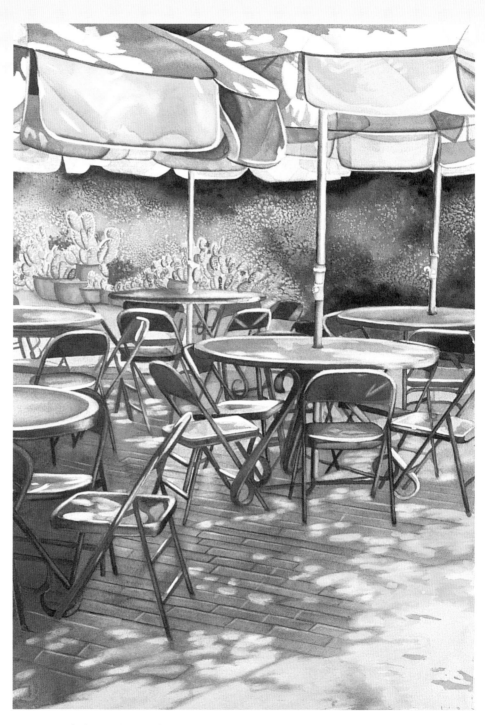

Finish the Background

9 Now think about the background. Paint the pots and cactus. Add another glaze on the foreground to break up the straight line of blue. Add the lines to the tiles on top of the glaze. Keep the warmness in the front, but the painting should gradually become cooler, as it goes toward the back to give the piece excitement, color and depth.

After I did this I was happier! I needed
to start out with deep rich color in the
shadow areas in order to make this
painting work. It's hard at first, but try to
exaggerate what you see. Intensify your
colors and you will be amazed. It's nice
when I look at this painting—I can still feel
the soft, breezy spring day. It was a lovely
place to be, with nice memories.

❧

10 Adjust the Background

The background is too warm and light. Also, the salt makes
the painting look too busy, so soften the background. There
is also a lack of depth. The pots are too warm and bright to be back there.
Use a complementary glaze of blue over the orange areas to tone down
the pots and cool down the cactus.

San Juan Baptista Shadows · *Watercolor on Arches 300-lb. (640gsm) cold-
press paper* · *15" x 22" (38cm x 56cm)*

Summer Shadows

Palette

Alizarin Crimson ◆ Burnt Sienna ◆
Cadmium Red Orange ◆ Cadmium Scarlet ◆
◆ Cobalt Turquoise ◆ French Ultramarine Blue ◆
Golden Lake ◆ Indigo ◆ Leaf Green ◆
New Gamboge ◆ Payne's Gray ◆ Perinone
Orange ◆ Phthalo Green ◆ Rose Violet ◆
Sap Green ◆ Sepia ◆ Ultramarine Deep ◆
Warm Sepia ◆ Winsor Violet

Reference Photograph

■ In *Summer Shadows* I wanted that look of a hot summer day with lots of color. White chairs can be a challenge to paint and still capture color in them. Normally the shadow is on top of the ground—you paint the ground first and your shadows rest on top. I wanted this composition to be a little more painterly in appearance. I had the choice of leaving it very colorful, which I sometimes do, or painting it with a more realistic approach.

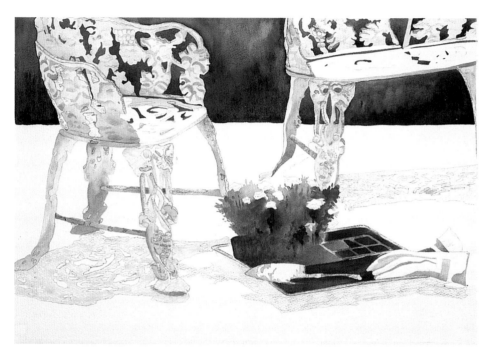

Establish the Darks

1 Complete a line drawing of the reference photo. Be sure to include your three values. Gently erase it and apply masking fluid to cover some of the sharpest whites in the shadows on the ground. The masking fluid in the shadows will ensure a clean, crisp underpainting. After the masking fluid dries, erase some of the graphite lines.

Begin the painting with the darkest darks, so you can compare your values to the white chairs. It's very easy to paint white objects darker than they should be if you don't have your darks already established. Use Sap Green mixed in different combinations with Payne's Gray, Warm Sepia, Indigo and Alizarin Crimson. If that's not dark enough use a mixture of Phthalo Green knocked down with Alizarin Crimson or Indigo. This will create a rich, dark green that will be either warm or cool. In the warmer areas, use Sap Green unmixed. This warm color will be prominent against the cool background, which enhances the contrast. Remember, warm colors come forward, cool colors recede. Paint the foreground leaves with warm Leaf Green.

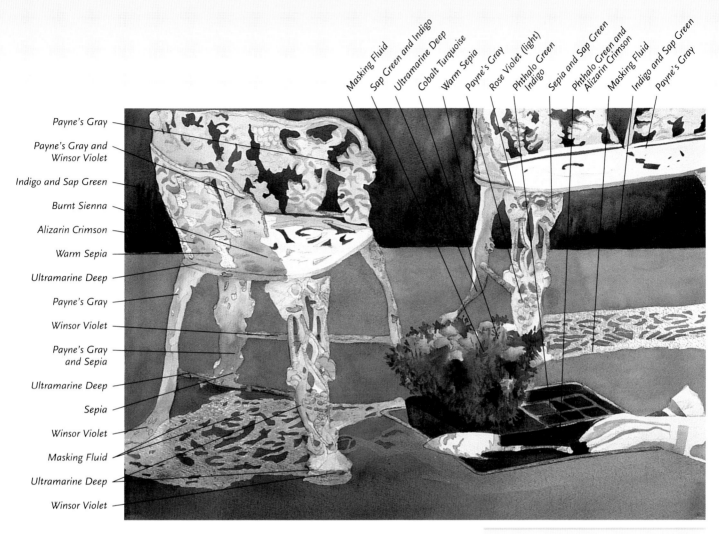

Labels pointing to the left chair (top to bottom):
- Payne's Gray
- Payne's Gray and Winsor Violet
- Indigo and Sap Green
- Burnt Sienna
- Alizarin Crimson
- Warm Sepia
- Ultramarine Deep
- Payne's Gray
- Winsor Violet
- Payne's Gray and Sepia
- Ultramarine Deep
- Sepia
- Winsor Violet
- Masking Fluid
- Ultramarine Deep
- Winsor Violet

Labels pointing from the top (left to right):
- Masking Fluid
- Sap Green and Indigo
- Ultramarine Deep
- Cobalt Turquoise
- Warm Sepia
- Payne's Gray
- Rose Violet (light)
- Phthalo Green Indigo
- Sepia and Sap Green
- Phthalo Green and Alizarin Crimson
- Masking Fluid
- Indigo and Sap Green
- Payne's Gray

2 Underpaint the White Chairs

Apply a very light wash to the white chairs. Don't go too dark yet; white is tricky to paint. You don't want the shadows on the chairs to be plain Payne's Gray. Add color to the chairs using light glazes, going darker as the painting progresses.

Paint the ground using large washes of Warm Sepia mixed with Cadmium Scarlet in the foreground and Sepia mixed with a little French Ultramarine Blue in the background in a lighter value to create a sense of depth.

AN ARTIST'S LIFE

Every year I buy flowers and set them out to plant and every year they stay right there by the chairs or some other place on my patio. They never seem to get in the ground. I bring them home from the nursery and place them where I think they would make a great painting. I end up leaving them there while I paint the painting instead of planting the flowers.

❧

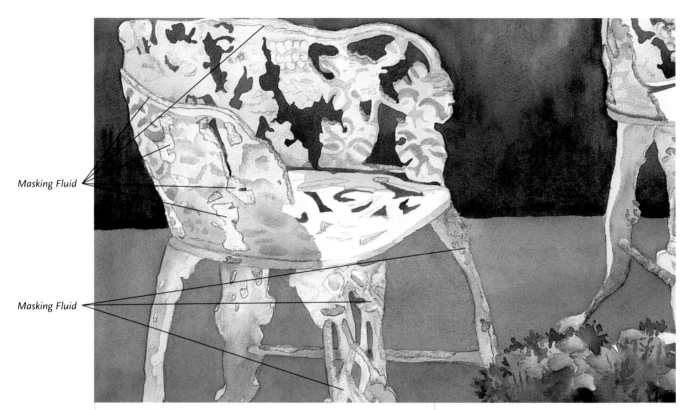

Masking Fluid

Masking Fluid

Focus on the Shapes

Notice the colors without any details. At this stage it's important to concentrate on shapes and values rather than the details. It's like making a cake. It's important to bake the cake before you frost it. Most of the time a cake looks spectacular after it is frosted, but you must bake it correctly first. The same goes for painting. Don't put your frosting on too soon—make sure your painting is done right before you get to the details.

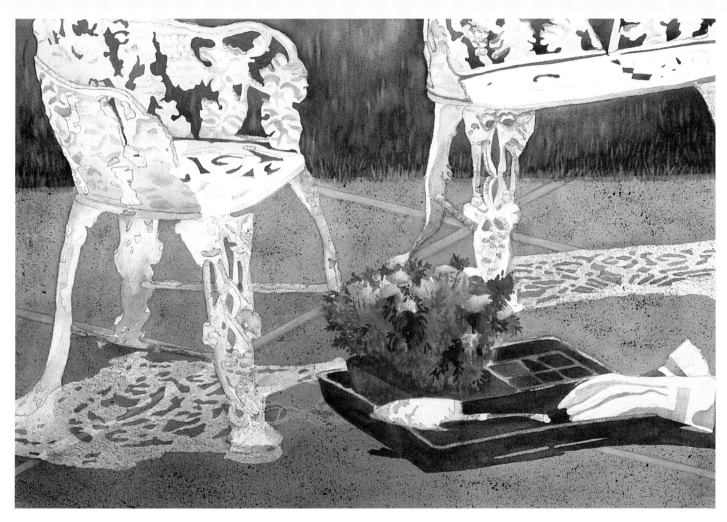

Soften the Background

3 When the background is dry, take your flat scrub brush and lift out some of the grasses. Do most of the lifting in the front of the grass and let it fade and soften toward the back.

Mix a very dark (number 8 value) Sepia. Cover up the parts of the white chair and the flowers with a paper towel and drafting tape. Use a toothbrush to splatter the ground with the Sepia at a number 8 value.

Paint the marigolds with Cadmium Red Orange on the bottom of the flower, Golden Lake in the middle and New Gamboge on the top. You want your dark values on the bottom and your lighter values on the top. Review it when you are done to make sure all the flowers are different. If they are not, change some.

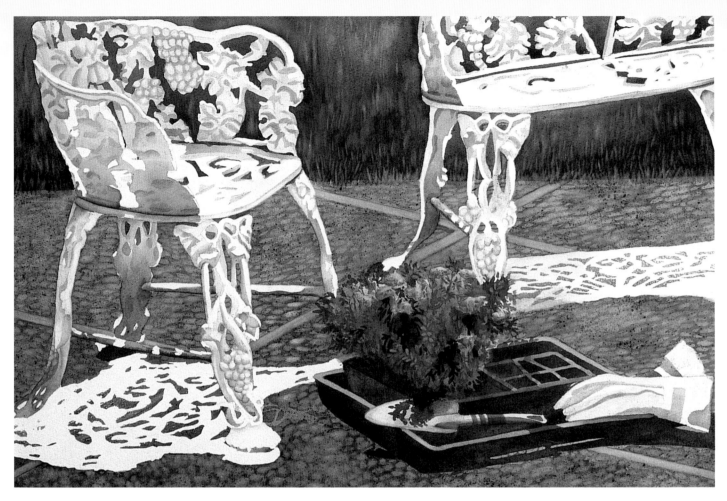

4 Add Texture
The painting looks a little dull, so add some texture to the ground. Negatively paint the gravel areas with dark Warm Sepia in the foreground and a cooler Sepia toward the back.

Add Detail

5 Take your round scrub brush and lift some very light areas off the pebbles to create a little more form. Add some leaves to the flowers as well. Use opaque warm Leaf Green and some Sap Green to paint the positive shapes of the leaves.

The shadows in the chairs should be more colorful and a little darker. Use (from left to right) Rose Violet to Payne's Gray to Winsor Violet, then a little Rose Violet to Perinone Orange to Payne's Gray. This gives the chair a more sunlit effect as well as some more color. Negatively paint around the shovel and gloves to shape them a little more. Create an underpainting to the shadows on the ground.

French Ultramarine
Blue and Tyrian Rose

Perylene Maroon and
Cadmium Red Orange

Blue Violet and French
Ultramarine Blue

Rose Violet and
Warm Sepia

Sap Green and
Payne's Gray

Perylene Maroon

Indigo to French
Ultramarine Blue
to Green Blue

6 Underpaint and Overpaint the Chair Shadows

Underpaint the shadow using the color-to-color technique and the colors listed on the painting. When the shadow underpainting is dry, glaze over it with Warm Sepia with a touch of Rose Violet. The Rose Violet calms down the color and darkens it a bit to make it look more like a shadow. Use a soft watercolor brush so you don't disturb the underpainting colors.

7 Deepen the Color

Strengthen the colors on the chairs. Inside the chairs, soften a few edges.

Summer Shadows · *Watercolor on Arches 300-lb. (640gsm) cold-press paper* · *15" x 22" (38cm x 56cm)*

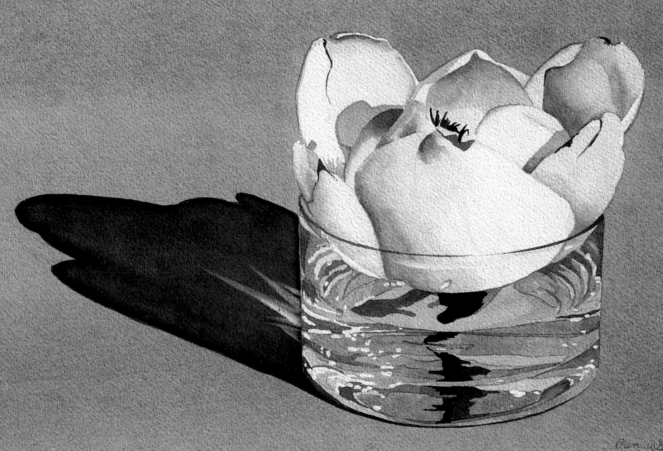

Water
Reflections

Seeing color in reflections and looking for unusual shapes and patterns is half the fun of being an artist! Exaggerating it is even more fun. You can let your imagination go and look for different, out-of-the-ordinary colors, abstract shapes and patterns. If you think of water as a mirror, reflections are easy to paint. To understand this better, take a small mirror, lay it on a table and set something on top of it to study. Now try and draw all the little nuances.

Water is much the same way, only there are ripples, lines, shapes and patterns to make it even more interesting. Go to a lake on a sunny day and look for reflections of different things in the water. Look at boats, trees, ducks, clouds, anything in the water. Remember when you were a kid and looked for different animals and shapes in clouds? Well, I still do, but I also look for things in different places as well, like water. Loads of fun!

This is the same thing. Try to see different shapes in the reflections, then look for colors. Try to relate the colors you see to the names of your palette colors. Make it fun and exciting. Don't try and paint every little shape you see or you will drive yourself crazy. Let your imagination run wild. The more you paint and know your colors and what they can produce, the more creative you can be.

The most important thing is to get the shape of the reflected object correct and the right colors. Then you can add your own small touches. Dots and dashes of brilliant color can perk everything up. Sometimes I use Prismacolor pencils to add these accents, trusting my intuition. As long as the painting captures the right reflection of the object, you can put in as many dots and dashes as you wish to enhance your painting. Remember, this is a work of art, and the photograph will not be shown next to the painting—it needs to stand on its own. Turn your painting upside down to see if the reflection is correct. Look at it in a mirror or take a photograph of it. Above all, have fun with reflections. This chapter will show you a few that I had some fun with.

Flower in a Glass · *Watercolor on Arches 300-lb. (640gsm) cold-press paper* · *15" x 22" (38cm x 56cm)*

Boat Reflections

Palette

Avignon Orange ♦ Brilliant Violet (Smickel)

♦ Burnt Sienna ♦ Cadmium Yellow Medium

♦ Cobalt Blue Light ♦ Compose Blue ♦

Golden Lake ♦ Horizon Blue ♦ Indigo ♦

Payne's Gray ♦ Permanent Violet ♦ Perylene

Maroon ♦ Phthalo Green ♦ Quinacridone Gold

♦ Sap Green ♦ Sepia ♦ Quinacridone Burnt

Scarlet ♦ Ultramarine Deep ♦ Ultramarine

Turquoise ♦ Warm Sepia ♦ Winsor Red

■ A good place to see lots of color, different shapes and abstract patterns is water on a sunny day. In this particular photograph I liked the subtleties of the subject as it is, but it invited me to add more color.

First I analyzed the composition of the photograph. The boats and pier were pointing to the lower left-hand corner leading your eye out of the picture plane. I sat down and drew a loose quick study to decide how to bring the eye back into the picture plane. I decided to simply add another boat. I used the computer to scan the photograph, duplicated it and flopped the image of the boat. I cut out the top of the largest boat and placed it in on the right-hand side so it would stop your eye from leaving the picture. This gave me a good opportunity to study the revised composition. I immediately liked it.

Reference Photograph

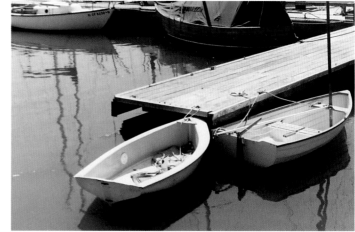

1 Complete the Drawing

Draw the image using the reference photograph on 300-lb. (640gsm) Fabriano Uno cold-press paper. This is a softer paper, which is good for this particular painting. Use the three-value tones in most places except in areas that are going to be very large and dark, like the reflections under the boats.

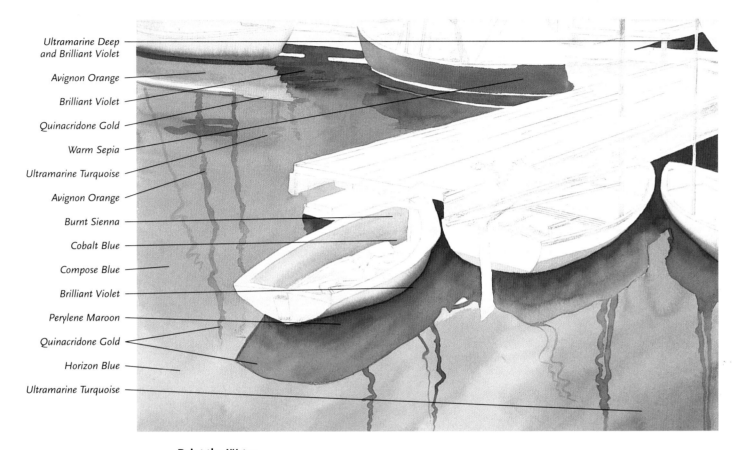

Ultramarine Deep
and Brilliant Violet

Avignon Orange

Brilliant Violet

Quinacridone Gold

Warm Sepia

Ultramarine Turquoise

Avignon Orange

Burnt Sienna

Cobalt Blue

Compose Blue

Brilliant Violet

Perylene Maroon

Quinacridone Gold

Horizon Blue

Ultramarine Turquoise

2 Paint the Water

Begin this painting with the green-blue of the water. At the top paint Ultramarine Turquoise, followed by Compose Blue and ending with Horizon Blue on the bottom. You want an overall feeling of the water before you place in the darks. Be aware of the gradation from dark at the top to light on the bottom. Allow this to dry, then add the rest of the underpainting.

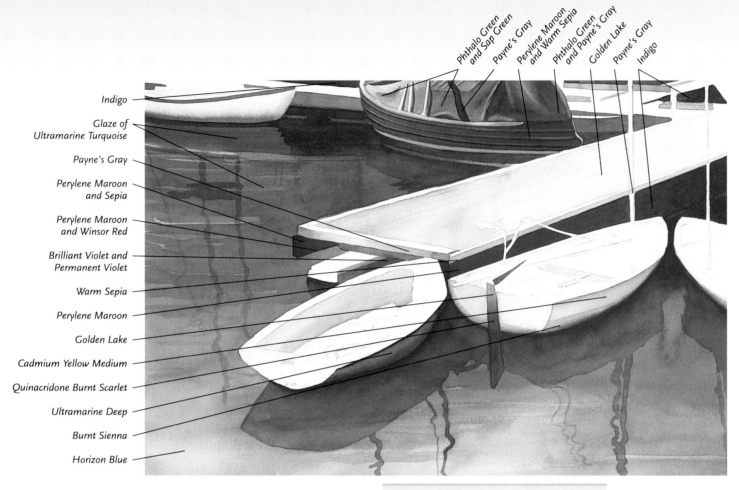

Indigo

Glaze of
Ultramarine Turquoise

Payne's Gray

Perylene Maroon
and Sepia

Perylene Maroon
and Winsor Red

Brilliant Violet and
Permanent Violet

Warm Sepia

Perylene Maroon

Golden Lake

Cadmium Yellow Medium

Quinacridone Burnt Scarlet

Ultramarine Deep

Burnt Sienna

Horizon Blue

Phthalo Green
and Sap Green

Payne's Gray

Perylene Maroon
and Warm Sepia

Phthalo Green
and Payne's Gray

Golden Lake

Payne's Gray

Indigo

Build Up the Colors

3 Add a light glaze of Burnt Sienna on the dock and a variety of blue-greens to the boat in the back. Paint the boat in the back almost to completion to get a feeling for the painting. The darks help to establish the correct values. The middle boat will be the focal point, so glaze it with a deep yellow. This boat will eventually be red.

VIBRANT COLORS

Try and think of colors that will make your final color more vibrant. For instance, try New Gamboge under Winsor Red for the boat.

❧

4 Add Detail

Add some of the little things, like the background decking and another glaze on the large deck. You can use the same colors or change them! Just be mindful of complementary colors.

PAINT BEAUTIFUL COLOR, NOT MUD

There is so much emphasis on mud in watercolor painting. I have even read where some artists say not to mix a warm and a cool together. Huh? Too many rules ... and some rules are made to be broken! Try these things and see for yourself. Try mixing an ice-cold French Ultramarine Blue and a warm Sap Green together; the result you will see is a beautiful crisp blue-green. I think the key here is to plan things out beforehand. If you keep going over and over a color, eventually it will lose its brilliance, creating mud. Plan what you want to do, study your colors and be careful of complementary colors glazed or mixed with one another. If you plan before painting, you will get glowing colors. Try and make some mud colors without using complementary colors. I bet it will be harder than you think!

❧

Accent the Boats

5 Now put some emphasis on the boats. Block in the blue and a violet, then add the interior boat colors. Don't put in too much detail, because you want your attention on the colors. Basically, add dots and dashes of color. Be creative with your colors. That's half the fun!

6 Review Your Painting

Put your painting on the easel and study it. The eye wanders out of the picture plane in the upper right-hand corner. Add a piece of wood in this corner and a mast to the small red boat on the right to stop this wandering. This will help keep your eye from flying out of the picture. Apply another glaze to the reflections of the boats using the colors from the boats.

Use pastels to add some bright dots and dashes, but not too many. You still want to focus on the intense colors in the painting and the soft feeling of quiet and still reflections.

Dock of the Bay · Watercolor on Fabriano Uno 300-lb. (640gsm) smooth-press paper · 15" x 22" (38cm x 56cm)

Italy's Reflections

Palette

Alizarin Crimson ◆ Brilliant Pink ◆
Brilliant Violet ◆ Burnt Sienna ◆
Cadmium Scarlet ◆ Cadmium Yellow Orange
◆ Golden Lake ◆ Indigo ◆ Leaf Green ◆
New Gamboge ◆ Permanent Rose ◆
Payne's Gray ◆ Perylene Maroon ◆ Primary
Blue ◆ Pthalo Green ◆ Quinacridone Purple
◆ Rose Lake ◆ Sap Green ◆ Sepia ◆
Shell Pink ◆ Tyrian Rose ◆ Ultramarine Deep
◆ Warm Sepia ◆ Winsor Violet

■ My student, Theresa, is a professional photographer. Her excellent photography skills, in combination with her composition and knowledge of art, allowed her to produce this exquisite photograph. She was kind enough to bring it back from Italy for me to paint. I wish I could have been there to see the beauty of the reflections and the light.

This photograph will be tricky to paint, while maintaining a feeling of depth and color. This photograph has a feeling of crispness, light and colorful reflections reminiscent of Italy's beautiful glowing colors. I started first with a drawing on watercolor paper using three values. Notice how the planes go from dark in the foreground, to light in the middle ground (the side of the building) and then to middle value in the background (the distant buildings).

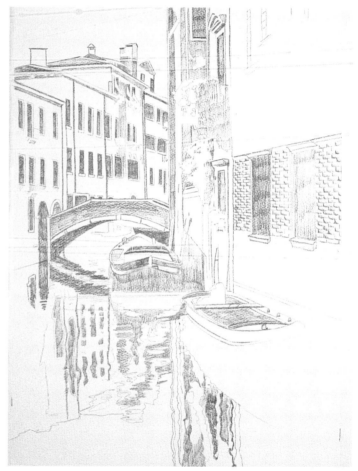

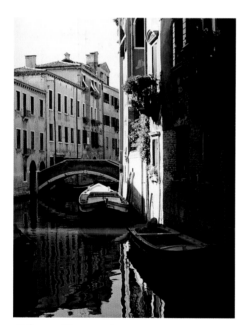

Reference Photograph

1 Complete a Value Drawing
Start with a drawing on watercolor paper using three values. Don't block in the very darks in the front, as this entire area is in shadow. Pay close attention to the shapes and perspective.

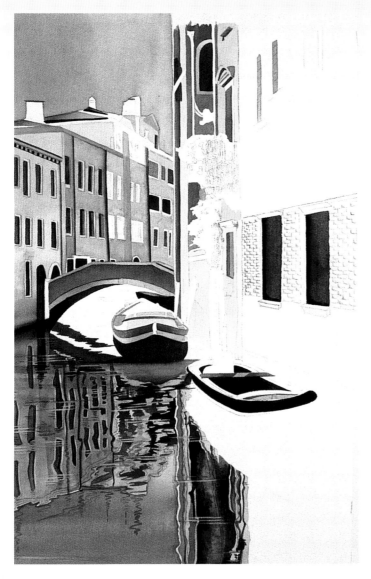

2 Complete the Underpainting

Start with an underpainting of the water and sky. Use Primary Blue and Ultramarine Deep on the water. Don't paint the reflections of the buildings yet; leave these for later in this step. Use Primary Blue and Payne's Gray in the sky.

Now paint the darks. Place your darkest darks first to set your values. Paint the underside of the bridge and the bottom of the boat using Indigo and Sepia in a number 8 value.

Use Sepia in different values to block in the buildings, creating a neutral underpainting. Study the reflections of the buildings on the water and paint the different shapes. Add the windows and lift out the window ledges using a scrub brush. Block in the bridge shape with Warm Sepia. Paint a bit of the middle ground buildings using Warm Sepia and Perylene Maroon.

Add the green reflection of the plants to the water under the boat. Use Sap Green and Payne's Gray. So far, very uninteresting colors.

Glaze Primary Blue over the building reflections and the rest of the water using a soft watercolor brush.

3 Establish the Darks

Mix a puddle of Perylene Maroon and Cadmium Scarlet for the top of the building on the right. Gradate down to Alizarin Crimson mixed with Perylene Maroon. Leave the brickwork in the middle of the painting the white of the paper, and paint the bottom half of the building using a combination of Indigo mixed with Perylene Maroon and a bit of Alizarin Crimson. When this is dry, paint the darkest darks in the shadowed part of the water using Indigo and Phthalo Green.

Lift out, ever so slightly, some vertical lines to represent reflections. Paint the boat using Ultramarine Deep and Primary Blue. Add some of the greenery on the building using Sap Green, Indigo and Leaf Green. Once these important darks are established you can relax and have some fun with color.

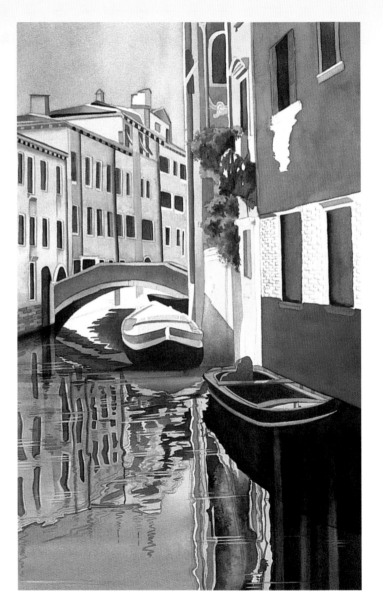

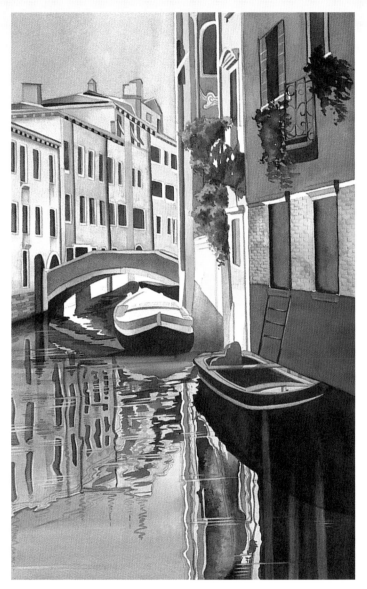

4 Add Detail

On the right side of the buildings paint the planter boxes and flowers. This is in shadow, so keep your colors toned down a bit. Use a dark value of Payne's Gray and Indigo for the shadow areas, and Indigo and Sap Green for the leaf area. Come back later with a very dark red/pink pastel for some flowers, drawing on top of the darks.

Move down to the brickwork on the building. Erase the bricks and shadows if you have not completely done so. Erase just enough to get the excess graphite off. Glaze Perylene Maroon mixed with Alizarin Crimson blending with Permanent Rose and then Cadmium Yellow Orange. Use the color-to-color technique. Let the paint set up for a few minutes and purposely add some watermarks to create texture. When this is completely dry, block in some of the bricks in a pattern with a darker value of Perylene Maroon and Alizarin Crimson.

Mix a big puddle of Indigo and Brilliant Violet. Make sure there is enough to glaze the whole building in shadow. When it is bone dry, take a large soft brush and glaze over the entire thing. Once this large dark area is done, go in and perk up other colors to the right values.

Use an underpainting of Tyrian Rose and Quinacridone Purple for the darks on the flowers. For the middle values use Permanent Rose. Again, you will be going over this with pastel to enhance the color and add detail later.

5 Complete the Overpainting

The last things to paint are the buildings. Start with a glaze of Burnt Sienna on the buildings on the left-side, painting all the way down into the water reflections. Don't apply any paint to the next building. On the third building, apply a glaze of Warm Sepia. Glaze the last building with Golden Lake to perk it up and repeat some of the golden yellows in the boats.

Glaze the front buildings on the right using Shell Pink mixed with New Gamboge for the peach buildings, and Brilliant Pink mixed with Rose Lake for the pinkish buildings.

Glaze the bridge using Burnt Sienna mixed with Perylene Maroon. Gradate the color so it's darker on the left and right sides and lighter in the center. When this is dry, use Golden Lake to glaze the light middle area. The top and bottom of the bridge are Payne's Gray mixed with Winsor Violet. Glaze it with a touch of Indigo to tone it down.

Go back into the painting with some pastel pencils and make dots and dashes to spark it up a bit. For the flowers, use a very brilliant pink and carry it down into the water so it looks like flower petals on top of the water. They are not in the reference photograph but will add to the picture. Spread them across the water and add a few other colors to perk up the water.

Italy's Reflections · *Watercolor on Arches 300-lb. (640gsm) cold-press paper*
30" x 18" (76cm x 46cm)

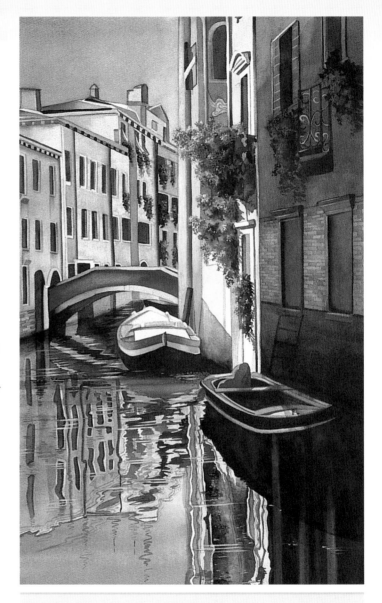

EXPAND YOUR COLORS

There's no reason to stay with the same colors, format or subject matter. Try something different. Try to break the rule and fix it so it works. Make your art exciting! Use new colors! You know what they will do because you studied them and did your charts! Mix your new colors with your old colors ... and most important of all, use your imagination and be creative! For the most part, I used the photograph but didn't copy every detail. I added colors I didn't see and things that weren't there. I eliminated some of the elements that were in the photograph.

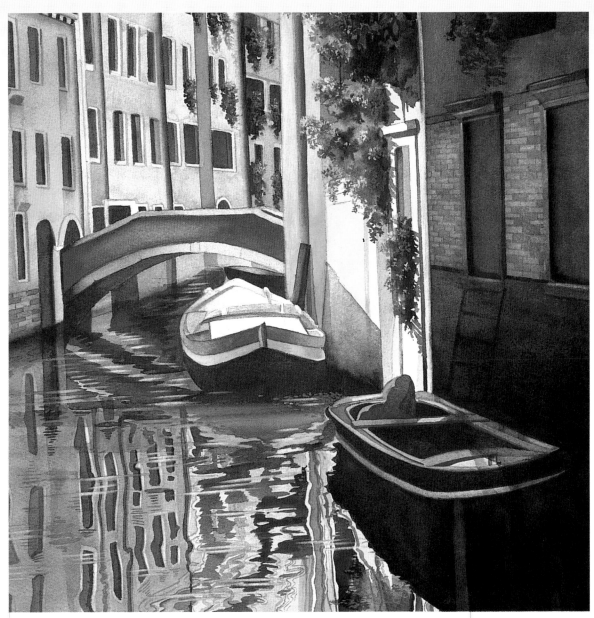

Critique

This was a challenging painting. The picture plane was divided vertically in half by the buildings. Fortunately, the bridge connects the two rows of buildings and unifies the painting. I really fell in love with the photograph and didn't want to change it, even though I knew I would be breaking one of my own rules. However, I could tell from my thumbnail that this would work. Try visualizing it without the buildings on the left. It would become a half-water and half-building painting. It's OK to break rules as long as you can justify it.

I like the lighting and colors in the painting and I feel like it captures a little bit of Italy. My rule of not splitting things in half was broken but I think it was justified and enhances this particular painting. Even though I used a lot of colors, I carried them throughout the painting to create harmony. Plus, I had loads of fun painting it! Another fun approach to painting is to find a photograph you would like to paint and print it out in black and white. Create your own colors. You will be truly amazed with what you produce.

Seeing Color in Reflections

Palette

Burnt Sienna ◆ Cadmium Scarlet ◆
Cadmium Yellow Orange ◆ Cobalt Turquoise ◆
Compose Blue ◆ French Ultramarine Blue ◆
Indigo ◆ Leaf Green ◆ New Gamboge ◆
Opera ◆ Permanent Rose ◆ Perylene Maroon
◆ Perinone Orange ◆ Phthalo Blue ◆ Phthalo
Green ◆ Primary Blue ◆ Rose Lake ◆ Sepia
◆ Tyrian Rose ◆ Ultramarine Deep
◆ Ultramarine Turquoise ◆ Warm Sepia
◆ Winsor Red ◆ Yellow Ochre

■ Seeing color in reflections is fun for the artist. Exaggerating the colors you see is even more fun! You can let your imagination go wild and look for unique shapes and colors, especially in water. Remember, if you think of water as a mirror, the reflections are easy to paint.

This is a great reference photograph for studying color. I really like the color combinations; especially the intense contrast of the swimsuits and skin tones against the blue-green of the water. I decided we would do something a little different this time and pour the colors for the water instead of painting them.

Reference Photograph

1 Sketch the Reference Photograph
Draw a three-value sketch of *Water Babies* directly on the watercolor paper. Erase the dark shadow side of the children. You will be painting the shadow side of the children first.

2 Underpaint the Skin Tones

Begin with a mixture of Permanent Rose and Yellow Ochre to paint the shadow side of the children. Make sure all the graphite is erased and carefully glaze each shadow individually. You don't want too much pencil to show through but if you erase the whole thing, the children's features will be hard to draw back in. So erase and paint each child separately. Leave the light side of the children the white of the paper. Don't think too much about values, just concentrate on blocking in the shadow shapes. Draw the light blue shapes of the water and then apply masking fluid to those shapes using an old brush. You want to mask them because you will be pouring on color.

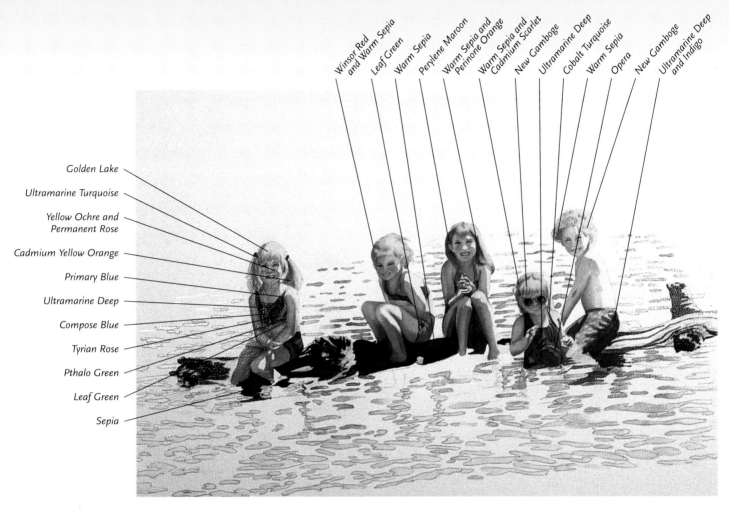

The labels pointing to the image read (left side, top to bottom):
Golden Lake
Ultramarine Turquoise
Yellow Ochre and Permanent Rose
Cadmium Yellow Orange
Primary Blue
Ultramarine Deep
Compose Blue
Tyrian Rose
Pthalo Green
Leaf Green
Sepia

The labels along the top, left to right:
Winsor Red and Warm Sepia
Leaf Green
Warm Sepia
Perylene Maroon
Warm Sepia and Perinone Orange
Warm Sepia and Cadmium Scarlet
New Gamboge
Ultramarine Deep
Cobalt Turquoise
Warm Sepia
Opera
New Gamboge
Ultramarine Deep and Indigo

3 Establish the Darks and Underpaint the Tree Trunk

Paint the darkest dark, which is the tree trunk in the water. Combine Sepia and Warm Sepia in a number 8 value for the darks, leaving the lights alone. Now that the darks are blocked in, it will give you a better idea of how intense the skin tones and swimsuits should be.

4 Mask the Paper and Pour the First Wash

Now the fun begins! Allow the underpainting to dry completely. Apply masking fluid to the children, the tree and some of the reflections. You have already masked the water shapes. Allow the masking fluid to dry.

Mix some New Gamboge in an 8-oz. plastic cup. Use about one level teaspoon of pigment, fill the cup almost to the top with water and mix it very well with a paintbrush. Test the color on the side of your paper to see if the value is correct. You want a light value, number 3 or 4. Take your painting to a sink or stationary tub and wet the entire sheet of paper with clean water using a large brush. When the shine has left the paper, pour on the New Gamboge mixture. Hold the paper (taped on a piece of foamcore) vertically and let the paint run. Only pour it on the bottom three-quarters of the painting, not the top area. Hold the painting any way you wish to help control the angle and rate of the flow. Flow the paint horizontally to help suggest water. Let the painting dry completely, possibly a couple of hours.

Pouring Color

Pouring on color is similar to a large wash, except that it's a little more fun and easier to do. You literally pour the color glazes on to get a nice even gradation and beautiful glowing color. Be sure to mask those areas you want to remain untouched.

❧

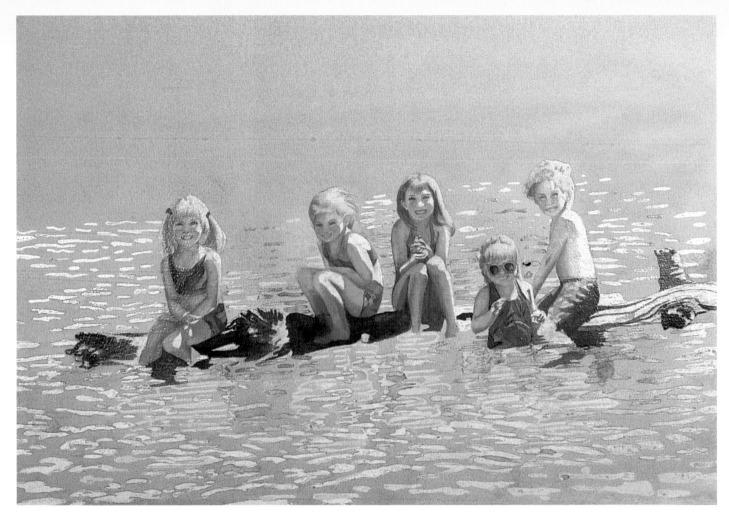

5 — Add the Blue Underpainting

Create a cup of French Ultramarine Blue and a separate cup of Phthalo Blue, as you did with the New Gamboge. Make both blues a number 4 value. Gently wet the paper with clean water, being careful not to disturb the New Gamboge. Pour the Phthalo Blue on the bottom three-quarters of the painting and the French Ultramarine Blue on the top one-quarter. Always test your color before you apply it, and remember it dries three times lighter.

Let the painting set up and help dry it with a hair dryer. There are some masking fluids that shouldn't be used with a hair dryer. I use Winsor & Newton, which works fine with the hair dryer. Test your masking fluid to see how it reacts to the extreme heat.

When it is completely dry, go back in and remove some of the masking fluid from the foreground using a rubber cement pick up.

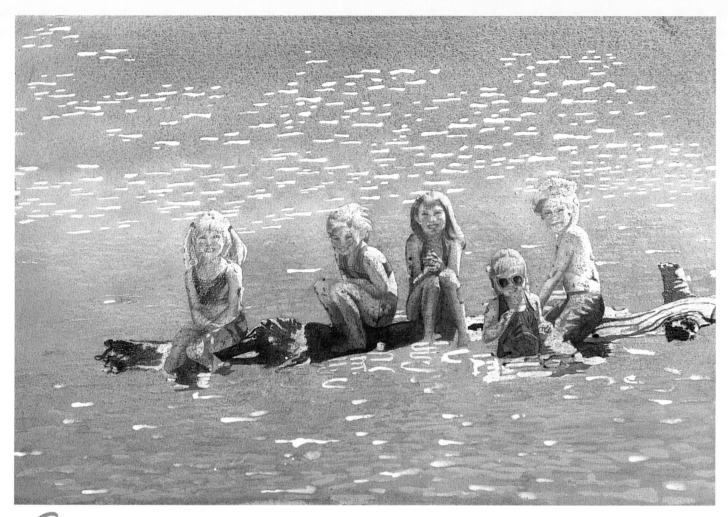

6 Pour the Overpainting

Mix three fresh cups of paint—French Ultramarine Blue, Phthalo Blue and New Gamboge. Gently wet the painting with clear water and apply the French Ultramarine Blue starting at the top of the painting. When you get one-quarter of the way down, switch to Phthalo Blue until you reach the last one-eighth of the painting, where you will use New Gamboge. Notice how the colors toned the paper in the foreground where the masking fluid was. Allow this to dry.

7 Overpaint the New Gamboge

Apply more masking fluid to the reflections in the top area of the water. Make your lines thinner this time, keeping the larger lines in the front and smaller ones in the back to create some depth.

The colors are working well, so mix the same pigments in a little stronger value. Evaluate the water area. The French Ultramarine Blue is not going as deep as it should be. Getting it as dark as it is needed is not possible because of the moderate intensity of French Ultramarine Blue—this blue isn't dark enough. So use this recipe for some artistic mixing: combine four parts French Ultramarine Blue Deep, two parts Winsor Violet and one part Payne's Gray, all in a number 6 value. This should make it the intensity you want.

Add a little of the New Gamboge to the bottom portion of the painting. Tilt the painting downward a little so you don't have dividing lines in it and the pigments run together just a little. Tilt it enough to get rid of the lines and make some nice shapes. Blend the colors carefully—you don't want bands of color in your painting.

Overpaint the Phthalo Blue

Add the Phthalo Blue to the middle of the painting by pouring it on, let it overlap the French Ultramarine Blue about one inch (25mm).

9 Finish Pouring On the Overpainting

Pour the French Ultramarine Blue mixture, letting it run over the top portion of the painting. Let this dry very well, for about an hour, and then dry it with a hair dryer. It is better to let it air-dry but we will be using a fixative to bring back a little of the depth after the painting is completely finished. Only apply the fixative when the painting is completely dry and you are finished painting it.

TAKE THE RISK

You have to trust your judgement sometimes when taking chances with your art. It's only a piece of paper but it's always good to practice first. The way I see it, if it doesn't work out, you have lost nothing. Make yourself do it over again and add it to your collection of practice paintings and drawings. Every painting is a part of your art experience. It's hard to paint something again, but it's so good for you. You usually do it better the second time around, and of course, with more experience!

10 Remove the Masking Fluid

After the painting is completely dry, use a facial tissue to gently wipe the excess paint off the masking fluid so it doesn't rub into the skin tones. Remove the masking fluid on the water in the background, the children and tree. The painting is still at a very raw stage (what I call the "uglies"). There are a lot of hard edges that need to be softened.

Go back to the children and lift out any spots where the blue had gotten under the masking fluid and soften the edges. Re-glaze the swimsuits and skin tones to make them brighter. Pay close attention to the location of the shadows on the children. Their bodies should be rounded instead of flat. There should be a thin strip of light on the edge of the light side to suggest roundness.

11 Exaggerate Some Color

Once the children and the tree trunk are done, focus on the water. Lift and soften some areas, leave some hard edges in the foreground and soften the ones fading in the background. When this is dry, add the colors of the swimsuits on top of the water reflections. Squint your eyes and look at the shapes of the reflections. Notice the colors you see and exaggerate them. Re-glaze the dark of the tree trunk using Warm Sepia and a little Burnt Sienna on the top of the tree. Let this dry completely.

Use Prismacolor pencils to add some dots and dashes. This adds sparkle to the water. Think about this carefully before you draw because once you add the colored pencil, it doesn't erase.

Water Babies · *Watercolor on Arches 300-lb. (640gsm) cold-press paper 22" x 30" (56cm x 76cm)*

CAPTURE THE FEELING

This finished painting gives me the feeling of a lazy hot summer's day with happy children, so I was satisfied with it. If you notice, every one of the children had a smile on their faces. I wonder why?

Critique of *Red Rhodes*

When I am almost finished with my painting, I stop and put it on an easel and study it for a while. Then I ask some questions. These were my thoughts on *Red Rhodes*.

Is my focal point popping out enough? What else can I do to make it really stand out?

I have decided that I want to use my airbrush and glaze over the background leaves on the left to push them back. I want to keep the details on the leaves, so the airbrush is the perfect tool. A light glaze of cool blue should do it!

When I squint my eyes I see that all three leaves are the same on the right side. I need to add some filtered light on the left side to balance it more and I want to change one of the leaves on the right.

What temperature percentages are present? Is it balanced in temperature and value?

This painting is 75 percent warm darks and 25 percent cool lights.

Are things formed well?

I need to glaze the sides of the buds a little darker to make them read round; they are not round enough. I will darken one side using a warm color with the airbrush so I can retain the detail.

The last thing I would do is take the flat scrub brush and soften the edges so they don't look pasted on. I love the dark, rich negative areas and am happy with those.

Do I have depth or different planes in my painting?

Yes, but once I glaze back a few things, it should work even better!

Do I have a variety of greens?

Yes, the underpainting solved that problem.

It really helps to study your painting and ask yourself questions like these.

CRITIQUE CHECKLIST

It really helps to study your painting and ask yourself questions like these.

- Is my focal point popping out enough?
- What else can I do to make the focal point really stand out?
- What temperature percentages are present?
- Is it balanced in temperature and value?
- Are things formed well?
- Do I have depth or different planes in my painting?
- Do I have a variety of greens?

Filtered Light

Red Rhodes uses filtered lighting. Notice how I glazed back the background to bring out the main red rhododendron. I wanted to accent the colors of the shadows on the leaves, so my underpainting was intense in the shadow areas and lighter in value in the light areas.

Red Rhodes · *Transparent watercolor on Arches 300-lb. (640gsm) cold-press paper · 22" x 30" (56cm x 76cm)*

Conclusion

Writing this book forced me to see all the things I take for granted as an artist and to appreciate how fortunate I am to have this gift. It helped me put my feelings about art into words, as well as made me think about every step of my process. I rediscovered the joy I feel when I find something I want to convey and more importantly, how to get the results I want.

This book is just a starting place for the beginner and something new for the more advanced artist. I hope the demonstrations in this book showed you my process. You should take my process and use your creativity to create art your own way. Expand upon it, educate yourself, study and practice. That is the only way you will become successful and happy with your art.

I hope this book portrays the love, enthusiasm and joy of painting as well as the trials and tribulations. When I am frustrated and have doubts about my work, I always go back to the basics. I cannot tell you how important it is to know your tools and your craft, as well as your subjects.

Remember, there is no right way or no wrong way to paint. The only rule you should follow is to paint what is in your soul, using all the knowledge you have. I spent a lot of years painting things I didn't love until I learned to follow my heart. Once I did, a whole new world opened up for me. Search for what you like as an artist and discover what inspires you. Don't be intimidated by artists who only follow rules. Ask yourself questions: Why do I like the light shimmering on the leaves? Why do I like the gentle flow of color in the flower or the vivid tonalities in some skin tones? Find out what makes you tick. See what inspires you and why.

I have shown you how to see colors—now go and experiment with your own choices. Remember, you can shout or whisper, it is all up to you. Look for the little nuances of things; I can't tell you how interesting and fulfilling that is. Dare to be different! Memorize your colors and values. Know your color temperatures. Learn all you can about the colors and the paints you use. They are the basis of great painting. Paint different subjects until you find what inspires you and makes you happy. This is the only way you will find your style.

I hope this book gives you a place to begin, a solid foundation and a good understanding of color and temperatures. Now go out into this big beautiful world and paint your heart out! May your paintings fill your soul with joy and happiness and be a reflection of you.

Waiting · *Watercolor on Arches 300-lb. (640gsm) cold-press paper* · *22" x 15" (56cm x 38cm)*

Index

Get more of the *best watercolor instruction!*

These books and other fine art titles are available from your local art & craft retailer, bookstore, online supplier or by calling 1-800-448-0915.

Packed with insights, tips and advice, *Watercolor Wisdom* is a virtual master class in watercolor painting. Jo Taylor illustrates every important technique with examples, sketches and demonstrations, covering everything from brush selection and composition to color mixing and light. You'll learn how to find your personal style, work emotion into your artwork, understand and create art and more.

ISBN 1-58180-240-4, hardcover, 176 pages, #32018-K

Beautifully illustrated and superbly written, this wonderful guide is perfect for watercolorists of all skill levels! Gordon MacKenzie distills over thirty years of teaching experience into dozens of painting tricks and techniques that cover everything from key concepts, such as composition, color and value, to fine details, including washes, masking and more.

ISBN 0-89134-946-4, hardcover, 144 pages, #31443-K

Create startling works of art that glow with color and light! Jan Fabian Wallake shows you how to master special pouring techniques that allow pigments to run free across the paper. There's no need to worry about losing control or making mistakes. Wallake empowers you to trust your instincts and create glazes rich in depth and luminosity.

ISBN 1-58180-161-0, hardcover, 128 pages, #31910-K

Create your own artist's journal and capture those fleeting moments of inspiration and beauty! Erin O'Toole's friendly, fun-to-read advice makes getting started easy. You'll learn how to observe and record what you see, compose images that come alive with color and movement, and make a travel kit for creating art anywhere, at any time.

ISBN 1-58180-170-X, hardcover, 128 pages, #31921-K